This book was originally a catalogue conceived and designed
by Dr Elisabeth Maxwell and Roman Halter to accompany the
exhibition of Original Drawings and Reproductions by
Victims of the Holocaust from Concentration Camps and Ghettos
1940 — 1945,
displayed at the Royal Institute of British Architects
in London, from 11 to 20 July 1988.

The exhibition was sponsored by the International Conference
"Remembering for the Future".

Exhibition and Catalogue
Designed and Assembled by

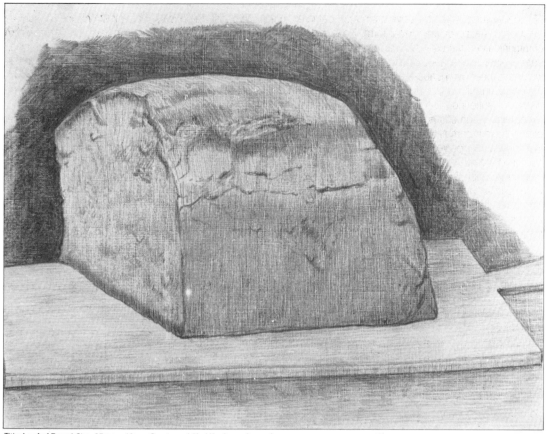

Title: **Loaf of Bread** *Size:* **25 cm x 16 cm** *Courtesy of:* **Yad Vashem, Jerusalem**
Ref: D.01

Ah, that bread! What rituals were not performed in the slicing of the loaf that was rationed out for a certain number—the man entrusted to slice it measuring it out adoringly by millimeters, another turning his back so he could not see the pieces while calling out the names of those to whom they were to be apportioned. They snatched their slices with exclamations of joy or anguish, depending on whether a man thought his portion slightly larger or slightly smaller than it should be, the tiniest differences elevated to impassioned quarrels, envenomed hatreds, sleepless nights. And, eternally, that hard choice: Should I eat my slice now or should I store it up for the next day, when the rations may be reduced still further or there may be no bread at all? And if I keep it overnight, where shall I hide it? Where can I put it so it won't be stolen?

I remember a man of about forty-five, a dignified man in spite of his emaciated state, who was in my barrack. He had a son of about twenty. One evening the son ate his own piece of bread, while the father placed his under a crumpled piece of cloth that served for a pillow. The next morning the father let out a stricken cry: his bread was gone. It was easy to see what had happened. The son, lying next to him, had eaten it during the night.

Samuel PISAR
Of Blood and Hope (p. 64)
Ref: W.00

The murder of 6 million Jews cannot be depicted in words, music or any visual form. No language or communication through Art can speak fully of this tragedy, nor evoke adequately those 6 million people who have been wrenched from us. In this exhibition of drawings, our aim is twofold: to show a fragment of that history of suffering, illustrating that even under those exceptionally gruesome conditions in ghettos and concentration camps, human beings could express themselves very powerfully in visual terms; and to carry out the dying wish of those millions, that they and the manner in which they died should be remembered. We were inspired by Felix Nussbaum, the artist, who, as he was taken from Theresienstadt to Auschwitz said to a companion who survived: "Make sure my work is seen by the public."

When Roman Halter and I first conceived the idea of this exhibition, we intended to include the work of survivors who still today express themselves in Art. We soon realised that our original idea - that of gathering works from a great many artists all over the world - was too ambitious if it were to be achieved in time for the conference. The practical solution, we felt, was to modify our plans and show instead a representative body of work produced by inmates of the ghettos and concentration camps in the period 1940-1945. These works, few as they are, succeed in conveying very powerfully the nightmarish reality of those times.

When we originally decided to mount this exhibition at the Royal Institute of British Architects, our immediate concern was that we might not have sufficient material to fill the available space. Thanks, however, to the generosity of the Director of the Auschwitz Memorial Museum, we now have the very opposite difficulty of having to exclude a great number of outstanding drawings through sheer lack of space. Reluctantly we had to exclude the few surviving drawings done by some of the 1 1/2 million Jewish children murdered in the Holocaust, with their moving depiction of the sun, flowers and butterflies, glimpsed through the barbed wire of the camp.

A group of original works forms the centre-piece of the exhibition, around which are displayed photographic reproductions of drawings which are too fragile and too precious to travel, collected from a number of public and private sources.

The artist's name is given in the catalogue, wherever attribution is possible, together with the provenance of the material. We have tried to accompany some of the drawings with a testimony or a survivor's eye witness account.

Amongst the works on loan from the Auschwitz Memorial Museum are three original watercolours which in themselves have a fascinating history. In 1945, when Auschwitz was liberated, 200 children were found in one of the blocks and the Polish authorities advertised for families in the vicinity to come forward and adopt them. One little girl, who is believed to have come from Hungary, disappeared into the block to fetch her belongings before leaving with her adoptive parents for a new life. She returned carrying a bundle into which another inmate stuffed a wad of papers. Some years later the Auschwitz Museum appealed for documentation and drawings from the Camp for its collection. The family came forward with the bundle of papers which proved to be the original watercolour portraits of gypsies in Auschwitz painted by Dinah Gottliebova (Babbitt), an artist who survived the camp and now lives in America. The Gypsies rounded up in Auschwitz were all gassed and cremated towards the end of the summer of 1944 and Dinah had been ordered to execute these drawings by the infamous Dr Mengele who was often in charge of the 'selections' and also carried out the horrendous pseudo-medical experiments on unsuspecting victims.

The drawings which have come down to us represent, of course, only a minute proportion of the artistic work which was done by the inmates. It is a miracle that they have survived, for most of their drawings have been lost for ever. We can only speculate, but it is estimated that the existing drawings represent a mere 2 percent of all the exceptional work done in the concentration camps and the ghettos between 1940-45. Though they speak of a world of Nazi-German inhumanity that belongs to the past, these artistic works reinforce our conviction that it is our duty to remember that past in order to build a safer, saner world for tomorrow.

The material which does survive comes mainly from the ghettos and the transit camps, particularly from Theresienstadt, Malines in Belgium and Gurs and Beaune-la-Rolande in France. In the concentration camps, the inmates were strictly prohibited from recording events happening around them and the penalty for anyone caught drawing without a specific order from a member of the SS or a Kapo was instant death. Prisoners who could draw would be ordered to sketch lice or bugs or fleas and their work would be made into posters with suitable captions, "Keep yourself clean, vermin can cause death". The very best draughtsmen were seconded to draw examples of the atrocities for the SS and we have illustrations of an SS officer holding a child by the hair with a pistol at its head and of the SS at roll-call brutalizing dying men. Such

drawings would then be taken by the SS to the School of SS Retraining in Posen (Poznan) to show to their colleagues as evidence of their own toughness and heartlessness.

From Auschwitz, for instance, the existing drawings and watercolours were almost all made by inmates selected by Mengele to record different types of malformation, birth marks or anatomical experiments, or simply the beauty of a gypsy girl who would later go to the gas chamber. From the Majdanek concentration camp, near Lublin which I visited with Roman Halter in search of further material, not a single drawing has survived, if any were ever made, but we saw there some photographs with special significance. Taken by an SS officer in contravention of strict orders, these photographs provide revealing evidence of SS brutalities, for he would take pictures of the inmates he had just murdered and even inscribed the date at the bottom of the photo.

It is only when we attempt to imagine the conditions under which these drawings were made that we fully appreciate the extent of the achievement. Even if the compulsion to record the activities of the camp became irresistible, the inmate had then to grapple with the practical difficulties. He or she had first to find a piece of paper, to get a piece of charcoal or a pencil or even just a splinter of wood dipped into some blackish liquid and, most importantly, search for a place where the material could be hidden, since their garb - the striped pyjamas or dress - had no pockets. These were the priorities and preoccupations which dominated the whole mind and being.

For, in that world of starvation, it was the fight for life itself which took precedence over everything else. How to avoid selection for the gas chamber, how to dodge beatings, kicks and a multitude of other punishments, how to fight the intense winter cold, the lice and the fleas, how to get the once-daily ladle of soup from the bottom of the cauldron where it was marginally more nourishing. To draw, to record under such conditions required extraordinary efforts of extraordinary human beings and the creative works they produced must obviously be viewed with all of this in mind. For these drawings do not belong to the usual world of art galleries and museums. They certainly would be out of place on walls in homes. Where do they belong, where should they be kept to teach of a past, to remind us for the future?

Apart from the visual history which the drawings communicate, the talent of their creators is immediately recognisable. Often with a few deft strokes they manage to depict a whole universe; the universe of the concentration camps where all human and humane values were turned upside-down.

They come to us from a world which we will never fully understand. Such is the inhumanity, such is the degradation conveyed by the drawings that our attention is almost totally riveted by the content and we tend to overlook the artistic technique. We are looking at victims, all in the depths of suffering and pain. We cannot help thinking of the brutal perpetrators of these crimes and, it seems, the mind switches to some dark past beyond the cave, beyond the walls of Lascaux, far, far away from the etchings of Goya....

Herein lies the paradox, for in this shared pain we are prompted to turn again and again to the drawings and sketches rather than to the more explicit quality of the photographs. We can observe and study the lines, and through the creative talent of the artist glimpse that other world which brought them into being. For within these lines lies the miracle of man himself. Forty-five years later, the power of these drawings is undiminished, for that very special quality, communicated to us with such vibrant immediacy, verges on timelessness.

Elisabeth Maxwell

Introduction
Ref. W.01

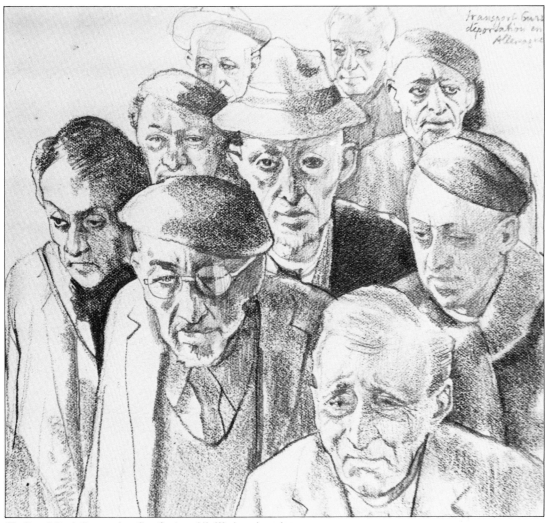

Title: **Deportation to Germany from Gurs** *Courtesy of:* **Yad Vashem, Jerusalem**
Ref: D.02

We remember our six million dead and all who died when evil ruled the world. We remember those we knew and those whose very name is lost.

We mourn for all that died with them; their goodness and their wisdom, which could have saved the world and healed so many wounds. We mourn for the genius and the wit that died, the learning and the laughter that were lost. The world has become a poorer place, and our hearts grow cold as we think of the splendour that might have been.

We stand in gratitude for their example of decency and goodness. They are like candles which shine out from the darkness of those years, and in their light we know what goodness is - and evil.

We salute those men and women who were not Jews, who had the courage to stand outside the mob and suffer with us. They, too, are Your witnesses, a source of hope when we despair.

In silence we remember those who sanctified His name on earth in dark times.

Ref. W.02

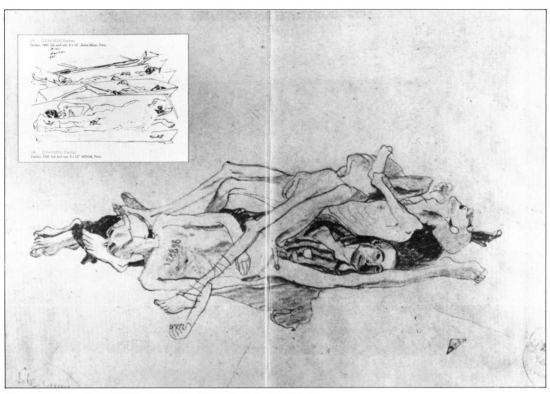

Title: **Corpses** *Author:* **Zoran MUSIC** *In:* **Dachau** *Size:* **20 cm x 30 cm** *Courtesy of:* **Author**
Ref: D.03

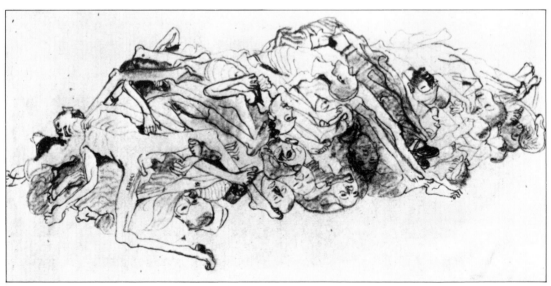

Title: **Two Hundred Cadavers, Not Yet Burned** *Author:* **Paul GOYARD** *In:* **Buchenwald, 1945**
Size: **12 cm x 20 cm** *Courtesy of:* **Yad Vashem, Jerusalem**
Ref: D.04

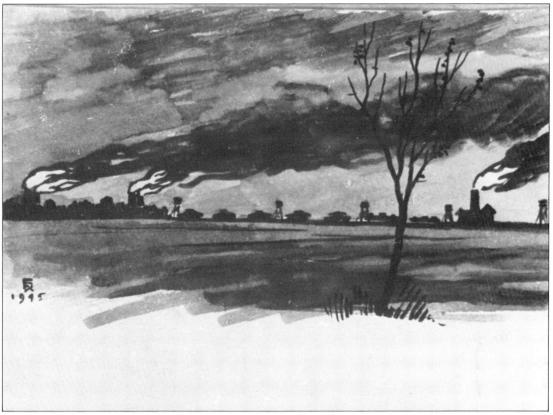

Title: **Crematoria** *Author:* **Karol KONIECZNY** *In:* **Buchenwald, 1945** *Size:* **29 cm x 20 cm** *Courtesy of:* **Yad Vashem, Jerusalem**
Ref: D.05

I n Hitler's Germany a particular code was widespread: those who knew did not talk; those who did not know did not ask questions; those who did ask questions received no answers.

from the writings of Primo LEVI
Ref. W.03

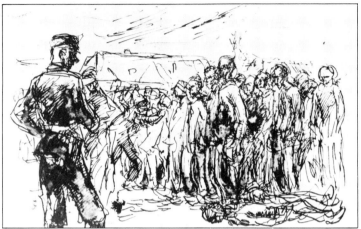

Title: **Roll-Call (i)** *Author:* **Mieczyslaw KOSCIELNIAK** *In:* **Auschwitz-Birkenau**
Size: **21 cm x 29.5 cm** *Courtesy of:* **Auschwitz Memorial Museum**
Ref: D.06

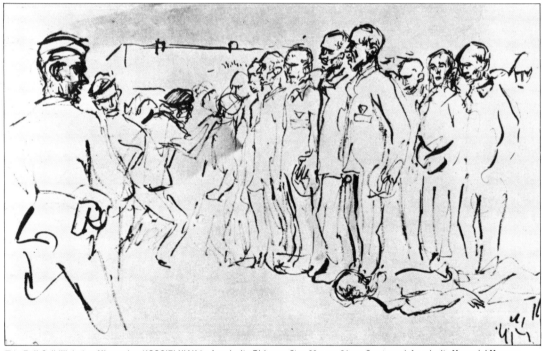

Title: **Roll-Call (ii)** *Author:* **Mieczyslaw KOSCIELNIAK** *In:* **Auschwitz-Birkenau** *Size:* **29 cm x 21 cm** *Courtesy of:* **Auschwitz Memorial Museum**
Ref: D.07

K OSCIELNIAK first made a lightning sketch (D.06) and then, inside the block, reduced and simplified the lines. We see clearly the block leader counting the men, the Kapo standing in front of the S.S., all the men standing to attention and the sick, dying and dead lying on the ground to be counted.

Ref: W.04

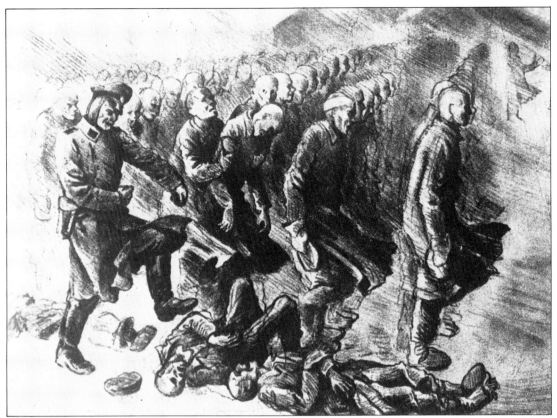

Title: **Roll-Call (iii)** *Author:* **Wincenty GAWRON** *In:* **Auschwitz, 1942** *Size:* **23.5 cm x 29 cm** *Courtesy of:* **Auschwitz Memorial Museum**
Ref: D.08

"Every roll call was a selection: women were sent to the gas-chamber because they had swollen legs, scratches on their bodies, because they wore eye-glasses or head kerchiefs. Young SS men prowled among the inmates and took down their numbers and during the evening roll call the women were ordered to step forward, and we never saw them again. Maria Keiler, a childhood friend and schoolmate, died that way. She had a scratch on her leg and an SS man took her number. When they singled her out at roll call, she simply walked away without even nodding goodbye. She knew quite well where she was going, and I knew it, too; I was surprised at how little upset I was."

1943 recalled by Lena BERG
The Holocaust (p. 570) **M. Gilbert**
Ref: W.05

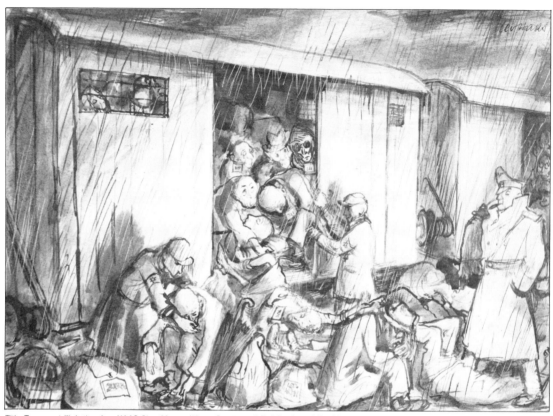

Title: **Transport (i)** *Author:* Leo HAAS *Size:* **20 cm x 15 cm** *Courtesy of:* **Beit Loghamei Haghetaot**, Israel
Ref: D.09

"We saw the unsealing of the coaches and the soldiers ordering men, women and children out of them. We then witnessed heart-rending scenes, old couples forced to part from each other, mothers made to abandon their young daughters, since the latter were sent to the camp whereas mothers and children were sent to the gas-chambers.

All these people were unaware of the fate awaiting them. They were merely upset at being separated but they did not know that they were going to their death. To render their welcome more pleasant at this time - June, July 1944 - an orchestra composed of internees - all young and pretty girls, dressed in little white blouses and navy blue skirts - played, during the selection on the arrival of the trains, gay tunes such as 'The Merry Widow', the 'Barcarolle' from The Tales of Hoffmann, etc. They were then informed that this was a labour camp, and since they were not brought into the camp they only saw the small platform surrounded by flowering plants. Naturally, they could not realise what was in store for them."

Madame C.V. COUTURIER, 1944 Auschwitz-Birkenau
The Holocaust (p. 686) **M. Gilbert**
Ref: W.06

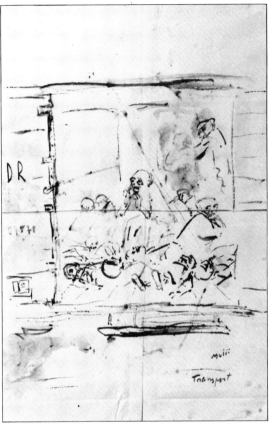

Title: **Transport (ii)** *Author:* **Zoran MUSIC** *In:* **Dachau, 1945**
Courtesy of: **Author**
Ref: D.010

"Piled up in freight cars, unable to bend or to budge, sticking one to the other, breathless, crushed by one's neighbour's every move, this was already hell. During the day, a torrid heat, with a pestilential smell. After several days and several nights the doors were opened. We arrived worn out, dehydrated, with many ill. A newborn baby, snatched from its mother's arms, was thrown against a column. The mother, crazed from pain, began to scream. The SS man struck her violently with the butt end of his weapon over the head. Her eyes haggard, with fearful screams, her beautiful hair became tinted with her own blood. She was struck down by a bullet in her head."

Albert HOLLENDER's testimony about events in 1942
The Holocaust (p. 437) **M. Gilbert**
Ref. W.07

With each arriving train from Hungary, selections were made, and some men and women from each train were sent to the barracks. But within a few days, twelve thousand Jews were being gassed and cremated every twenty-four hours. Alter Feinsilber, one of the few survivors of the Sonderkommando at Birkenau, noted, of these Hungarian transports:

"If the number of persons to be gassed was not sufficiently large, they would be shot and burned in pits. It was a rule to use the gas-chamber for groups of more than two hundred persons, as it was not worth while to put the gas-chamber in action for a smaller number of persons. It happened that some prisoners offered resistance when about to be shot at the pit or that children would cry and then SS Quartermaster Sergeant Moll would throw them alive into the flames of the pits.

I was eye-witness of the following incidents: Moll told a naked woman to sit down on the corpses near the pit, and while he himself shot prisoners and threw their bodies into the flaming pit he ordered her to jump about and sing. She did so, in the hope, of course, of thus saving her life, perhaps. When he had shot them all, he also shot this woman and her corpse was cremated."

Alter FEINSILBER's testimony about events in 1944
The Holocaust (p. 675) **M. Gilbert**
Ref. W.08

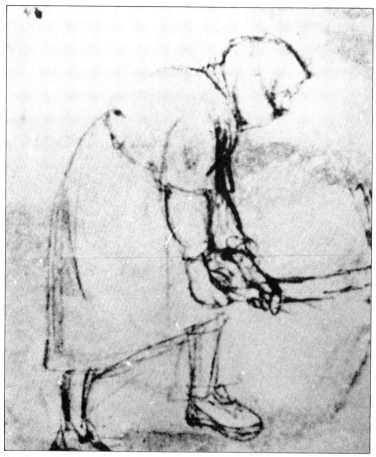

Title: **Woman with Pick-axe** *Author:* **Jadwiga SIMON-PIETKIEWICZOWA** *In:* **Ravensbrück, 1943**
Size: **10.5 cm x 7.5 cm** *Courtesy of:* **Lie Caly Omre, published by Ksiazka i Wiedza, 1975**
Ref: D.011

"It was in Buchenwald that I learnt from Jews, Christians, Moslems and pagans, from Englishmen, Serbs, Rumanians, Albanians, Poles and Italians that I was only one more suffering insignificant man; that the tongue my mother taught me, and my Hungarian memories and the traditions of my nation, were nothing but artificial barriers between myself and others.

I learnt that within me, as in others, the murderer and the humanitarian exist side by side; the weak child with the voracious male. That I am not in any way superior, that I am not different from others, that I am but a link in the great chain, was among the greatest discoveries of my life. From then on I resolved to support those who fell, even as I had been supported. When someone was despicable, greedy and selfish, I remembered all the occasions when I, too, had been despicable, greedy and selfish. Buchenwald taught me to be tolerant of myself, and by that means tolerant of others. It may be that I would have learnt this without the lesson of Buchenwald. But I would have learnt it much later - perhaps too late."

Eugene HEIMLER
Born in Hungary 1922. Poet, writer
and psychiatric social worker. Settled in
England in 1947 after surviving Auschwitz
Ref. W.09

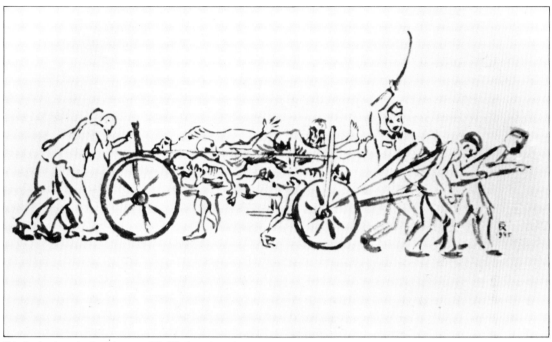

Title: **Carting Away the Dead** *Courtesy of:* **Yad Vashem, Jerusalem**
Ref: D.012

"Every night a truck, carrying a harvest of dead from Auschwitz to Birkenau, passed at right angles to the head of the ramp. Normally nobody saw what it held and it was gone before anyone could even think about it; but that night it was overloaded. That night it was swaying and heaving with the weight of dead flesh and, as it crawled over the railway lines, it began to bounce and buck on its tired, tortured springs.

The neatly packed bodies began to shift. A hundred, two hundred scrawny arms and legs flopped over the side, waving wildly, limply in a terrible, mocking farewell; and simultaneously from those three thousand men, women and children, rose a thin, hopeless wail that swept from one end of the orderly queue to the other, an almost inhuman cry of despair that neither threats, nor blows, nor bullets could silence.

With one, last desperate lurch, the lorry cleared the tracks, disappearing out of the arclights, into the darkness; and then there was silence, absolute and all-embracing. For three seconds, four at the most, those French people had glimpsed the true horror of Auschwitz; but now it was gone and they could not believe what their eyes had told them. Already their minds, untrained to mass murder, had rejected the existence of that lorry; and with that they marched quietly towards the gas-chambers which claimed them half an hour later."

The year 1942. The place, Auschwitz-Birkenau
Rudolf VRBA & Alan BESTIC
The Holocaust (p. 498) **M. Gilbert**
Ref. W.010

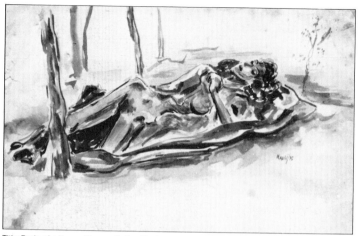

Title: **Body of a Young Woman** *Author:* **Marianne GRANT, formerly Mausi Hermann**
In: **Bergen-Belsen, Spring 1945** *Courtesy of:* **Author**
Ref: D.013

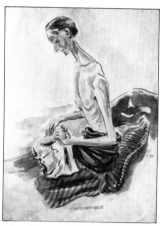

Title: **Delousing** *Author:* **Marianne GRANT, formerly Mausi Hermann**
In: **Bergen-Belsen, 1945** *Courtesy of:* **Author**
Ref: D.014

"One Sunday, when no one was going to work, an order was issued. Panic broke out once more. What now? We were all out in the yard when an announcement was made. We were terrified. The announcement was: 'You are about to witness what happens to a woman who wants to hide her Jewishness.' A beautiful blond woman was brought in with a noose attached to her neck and publicly hanged. Her crime? She was found walking in the street with her shawl covering her yellow star."

Maja ABRAMOVICZ (Zarch)
The Holocaust (p. 329) **M. Gilbert**
Ref. W.011

Title: **Children Playing with Ashes by the Crematorium** *Author:* **Marianne GRANT, formerly Mausi Hermann**
In: **Theresienstadt, 1943** *Courtesy of:* **Author**
Ref: D.015

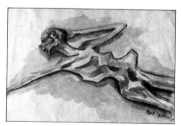

Title: **Dead Body** *Author:* **Marianne GRANT formerly Mausi Hermann**
In: **Bergen-Belsen, Spring 1945**
Courtesy of: **Author**
Ref: D.016

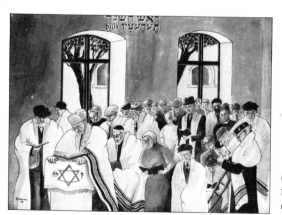

Title: **Amidah in Theresienstadt**
In: **Theresienstadt** *Courtesy of:* **Harry STEINHAUER**
Ref: D.017

Four pictures were brought back from Theresienstadt by Emil Spitz who survived for three years in the camp, most likely because he was a Master Baker by trade. We are showing one of these drawings which depicts Leo BAECK, seated behind the man who leads the prayers.

Ref. W.012

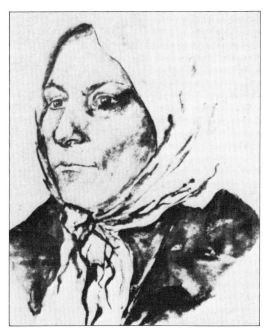

Title: **Gypsy from Poland** *Author:* **Dinah GOTTLIEBOVA**
In: **Auschwitz-Birkenau, 1944** *Size:* **38 cm x 31 cm**
Courtesy of: **Auschwitz Memorial Museum**
Ref: D.018

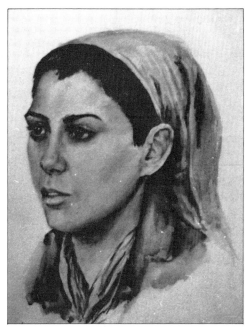

Title: **Gypsy from France** *Author:* **Dinah GOTTLIEBOVA**
In: **Auschwitz-Birkenau, 1944** *Size:* **45.5 cm x 38 cm**
Courtesy of: **Auschwitz Memorial Museum**
Ref: D.019

One people that shared the fate of the Jews were the Gypsies. They, too, had been persecuted through the ages, and like the Jews, the Gypsies were isolated and liquidated, country by country. Unlike the Jews, however, they left almost no records of the atrocities committed against them, which were no less horrible. When the bloodbath was over, only pitiful remnants were left alive. The world hardly knew of their sufferings, nor is it fully aware today of their disappearance. Except for the few survivors, a whole people, unique in its life-style, language, culture, and art, was wiped off the face of the earth. There are no memorials to their dead or commemorations of their tragedy. The death of the Gypsy nation was more than physical; it was total oblivion.

Azriel EISENBERG
Witness to the Holocaust
Courtesy of The Pilgrim Press, New York, New York 1981
Ref. W.013

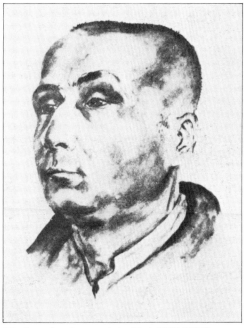

Title: **Gypsy from Germany** *Author:* **Dinah GOTTLIEBOVA**
In: **Auschwitz-Birkenau, 1944** *Size:* **33 cm x 26 cm**
Courtesy of: **Auschwitz Memorial Museum**
Ref: D.020

Title: **Scorched fragments from a Holy Book found in the ashes of one of the Auschwitz Crematoria**
Courtesy of: **Chief Rabbi Lord JAKOBOVITS**
Ref: D.021

Title: **Working Party** *Author:* **DAGHANI**
In: **January, 1943** *Size:* **28 cm x 15 cm**
Courtesy of: **Author**
Ref: D.022

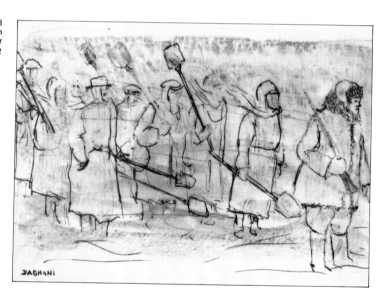

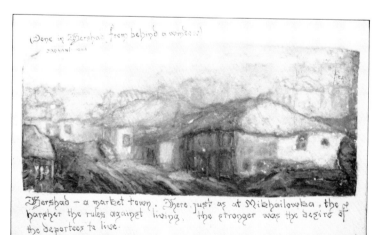

Title: **View of Berzhad from behind a Window**
Author: **DAGHANI** *In:* **Berzhad**
Courtesy of: **Author**
Ref: D.023

*Title:*The Revolt
Ref: D.024

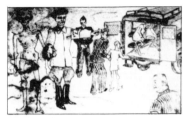

Title: The Selected
Ref: D.025

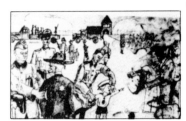

Title: Separation of Families
Ref: D.026

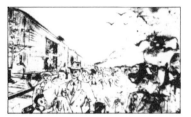

Title: Arrival of Transport at the Loading
Ramp
Ref: D.027

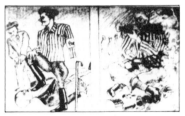

Title: Kapo Ruler
Ref: D.028

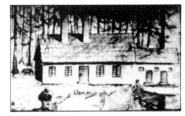

Title: Crematorium
Ref: D.029

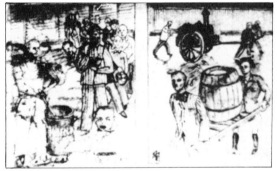

Title: The Distribution of Soup
Ref: D.030

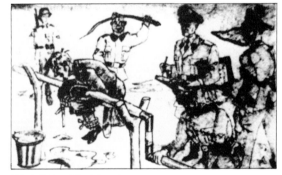

Title: Infliction of Punishment
Ref: D.031

The only original drawings found after the war in 1945 in Auschwitz-Birkenau were those in a sketch book of 22 pages which had been buried under the floorboards close to the foundations of the sick-bay block. The author is unknown.

(see also pages 60 & 61)

Ref. W.014

In 1944, 500 of us Jews and all metal workers from Lodz Ghetto were transported from the concentration camp of Auschwitz - Birkenau to Stutthof concentration camp.

Stutthof was situated near Gdansk and close to the Baltic sea. By comparison with Auschwitz it was so much smaller and when we arrived there and saw it for the first time it looked positively cosy. But very soon we were to find out how terrible it really was. For those who struggled to live, to survive from minute to minute, and that was most of us, the place was hell on earth.

We had 27 cms of sleeping space per person in addition to the lice and fleas, we were eaten up by bugs during the night, the food ration was smaller and worse than in Auschwitz and we were beaten often and severely. But what added enormously to our suffering was the cold.

The roll-call was between 7 and 7.15 am. Yet, we were forcibly chased out from our block at 5.30 am. Outside, dressed in our striped-pyjama-like outfits, we huddled to keep out the oncoming winter's winds and cold which cut painfully into our bodies. We realised that this was another form of torture, another way of murdering us. To mitigate the suffering from the cold we formed, what we then called a "human oven", by bunching together into circular groups and rotating in rhythm clockwise and anticlockwise stamping our clogs in unison. Those who were on the outside would after a while change place with those on the inside of the "oven".

But no sooner was our "human oven" formed than we would be charged at and beaten with sticks in order to make us disperse. No sooner was our punishment over, than our "human oven" would be quickly re-formed again, again and again.

One morning, after the arrival of a group of new inmates, immediately after the roll-call, the Kapo and block leader announced that numbers who could draw (for we no longer had names) should take three steps forward, adding that those found satisfactory would be able to stay inside the barracks before the roll-call and in addition would receive an extra piece of bread each day; there was a silent air of expectant hope, but no one moved. The Kapo repeated, extra bread and nice easy work inside the block for all who could draw.

Whispers of "Stay put! Stay put!" were heard: one learned to trust one's instincts and also to heed the warnings of the whisperers.

Suddenly a number of the newly arrived inmates felt that they could draw; a natural feeling prompted so powerfully by the promise of an extra piece of bread and warmth. All who took three paces forward were taken into the block for tests. Yes, drawing tests inside a concentration camp.

The old hands, the seasoned concentration camp inmates who knew a thing or two about a few yesterdays of Stutthof life said: "You will see them soon, all these instant artists, they will come out painted red all over." And they were right. For throughout that morning one by one they reappeared from the block bruised and bleeding. The price for failing the test was marked on their faces; and of course nearly all of them failed it. We felt deeply for them and we knew that after this stern and cruel beating they would not live long. It usually broke the springs of any man's hope. For under the terrible conditions of the camp life, the body did not have the power to recover from such a punishment without the help of hope.

The one or two who were retained had to draw bread, lice, bugs or fleas.

The SS were expressly forbidden to take photographs inside the camps but there was no order preventing them from using prisoners who were artists to draw brutalities of the SS choosing, which the SS would take with them to the re-training school in Poznan to show off to their colleagues their ability to torture and murder.

Testimony of Roman HALTER who was in
Lodz Ghetto, Auschwitz and Stutthof.
He now lives in London, England.
Ref. W.015

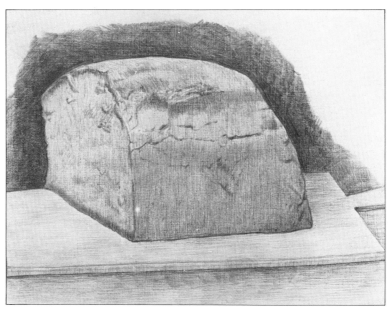

Title: **Loaf of Bread** *Size:* **25 cm x 16 cm** *Courtesy of:* **Yad Vashem, Jerusalem**
Ref: D.01

Title: **Louse** *Author:* **Unknown** *In:* **Auschwitz**
Courtesy of: **Auschwitz Memorial Museum**
Ref: D.032

Title: **Nazi and Child**
Author: **Waldemar NOWAKOWSKI**
In: **Auschwitz, 1943** *Size:* **12.5 cm x 10 cm**
Courtesy of: **Auschwitz Memorial Museum**
Ref: D.033

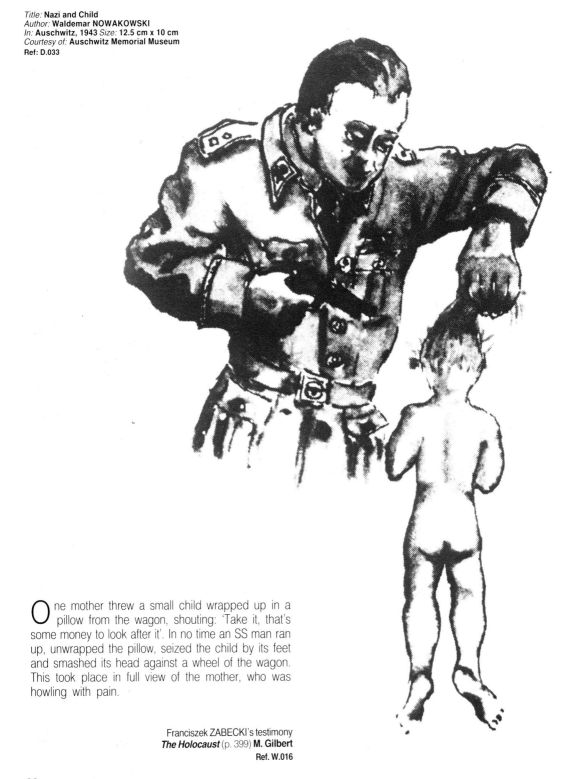

One mother threw a small child wrapped up in a pillow from the wagon, shouting: 'Take it, that's some money to look after it'. In no time an SS man ran up, unwrapped the pillow, seized the child by its feet and smashed its head against a wheel of the wagon. This took place in full view of the mother, who was howling with pain.

Franciszek ZABECKI's testimony
The Holocaust (p. 399) **M. Gilbert**
Ref. W.016

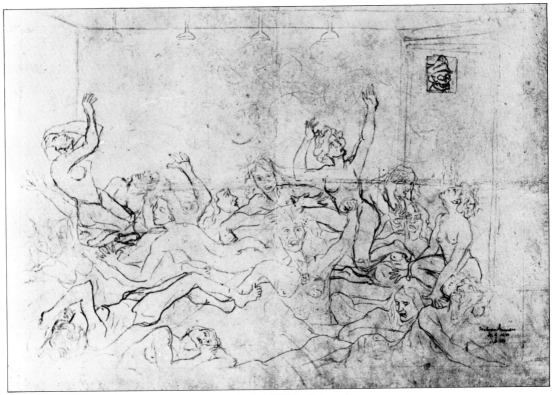

Title: **In the Gas Chambers** *Author:* **Wiktor SIMINSKI** *In:* **Sachsenhausen, 1944** *Size:* **35.5 cm x 61 cm**
Courtesy of: **Lie Caly Omre, published by Ksiazka i Wiedza, 1975**
Ref: D.034

The women all went into the barracks on the left and, as we later learned, they were told at once to strip naked and were driven out of the barracks through another door. From there, they entered a narrow path lined on either side with barbed wire. This path led through a small grove to the building that housed the gas-chamber. Only a few minutes later we could hear their terrible screams, but we could not see anything, because the trees of the grove blocked our view.

Jakob KRZEPICKI
The Holocaust (p. 458) **M. Gilbert**
Ref. W.017

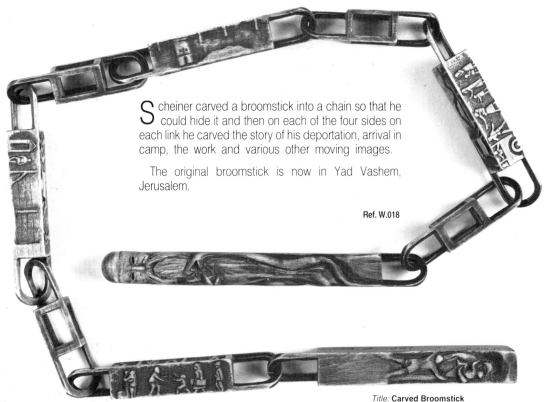

S cheiner carved a broomstick into a chain so that he could hide it and then on each of the four sides on each link he carved the story of his deportation, arrival in camp, the work and various other moving images.

The original broomstick is now in Yad Vashem, Jerusalem.

Ref. W.018

Title: **Carved Broomstick**
Author: **M. SCHEINER**
In: **Camp de Beaune La Rolande, 14 May 1941**
Courtesy of: **Yad Vashem, Jerusalem**
Ref: **D.035 - D.042**

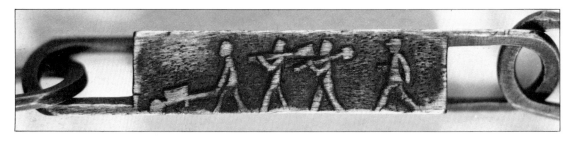

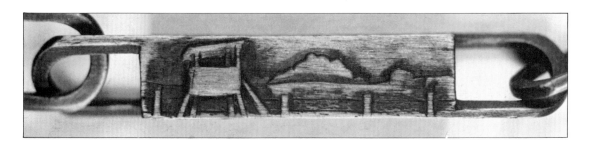

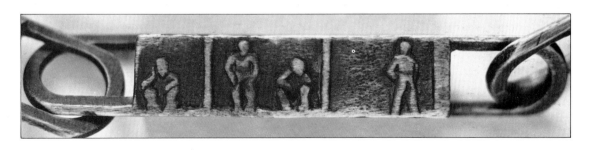

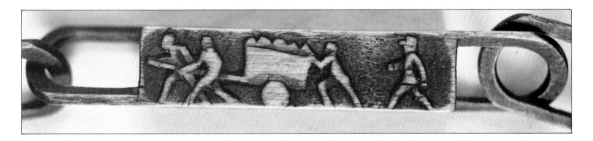

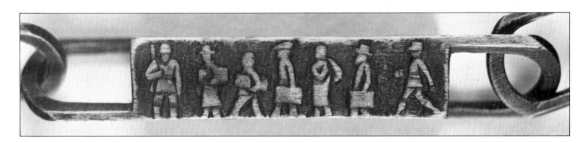

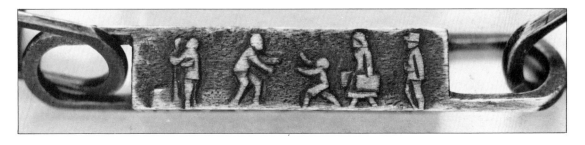

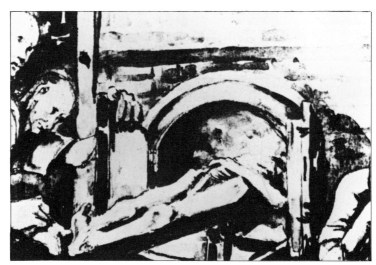

Title: **The Crematorium of Buchenwald (i)** *Author:* **Unknown** *In:* **Buchenwald**
Courtesy of: **Lie Caly Omre, published by Ksiazka i Wiedza, 1975**
Ref: D.043

"Barrack 25 got no food. Prisoners sat there locked up for hours, sometimes for days, without food, without a swallow of water, without toilet facilities, dying before their deaths. For Auschwitz was governed by a strict rule: Berlin always had to confirm the gassing of those selected and, occasionally, confirmation was delayed. Berlin had plenty of other things to attend to.

From that death barrack came screaming and lamentation, 'Water, for God's sake, a little water.' But no one responded. No one walked over to that barrack, no one ever gave the dying water. Helplessly, hands stretched out between the bars, imploring, but in vain. Barrack 25 was taboo.

When it was dark the trucks came for them, headlights flashing, engines roaring up, then silenced. When the engines started again, there was the screaming, the last horrible cries of the women taken to the gas-chamber."

Lena BERG's account about Auschwitz-Birkenau, 1944
The Holocaust (p. 729) **M. Gilbert**
Ref. W.019

"The boys undressed, instinctively afraid of death, naked and barefooted they herded together in order to avoid the blows and did not budge from the spot. One brave boy approached the Kommandofuhrer [standing] beside us [...] and begged him to spare his life, promising he would do even the hardest work. In reply he hit him several times over the head with the thick club.

Many boys, in a wild hurry, ran towards those Jews from the Sonderkommando, threw their arms around the latter's necks, begging for help. Others scurried naked all over the big square in order to escape from death. The Kommandofuhrer called the Sergeant with a rubber truncheon to his assistance.

The young, clear, boyish voices resounded louder and louder with every minute when at last they passed into bitter sobbing. This dreadful lamentation was heard from very far. We stood completely aghast and as if paralysed by this mournful weeping.

With a smile of satisfaction, without a trace of compassion, looking like proud victors, the SS men stood and, dealing terrible blows, drove them into the bunker. The sergeant stood on the steps and should anyone run too slowly to meet death he would deal a murderous blow with the rubber truncheon. Some boys, in spite of everything, still continued to scurry confusedly hither and thither in the square, seeking salvation. The SS men followed them, beat and belaboured them until they had mastered the situation and at last drove them [into the bunker]. Their joy was indescribable. Did they not [have] any children ever?"

Salman LEWENTAL's account about Auschwitz-Birkenau, 1944
The Holocaust (p. 749) **M. Gilbert**
Ref. W.020

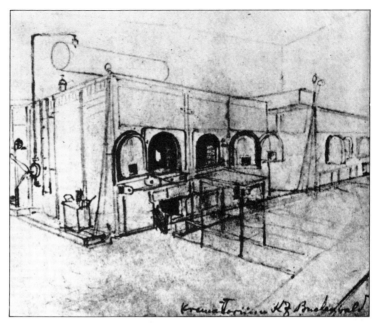

Title: **The Crematorium of Buchenwald (ii)** *Author:* **Unknown** *In:* **Buchenwald 1945**
Size: **10 cm x 18 cm** *Courtesy of:* **Lie Caly Omre, published by Ksiazka i Wiedza, 1975**
Ref: D.044

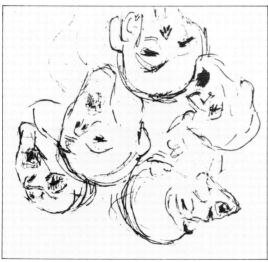

Title: **Inside the Crematorium** *Author:* **Per ULRICH** *In:* **Neuengamme**
Size: **14.5 cm x 10.5 cm**
Ref: D.045

"The gas-chamber was crowded with Jews and one Jewish boy remained outside. A certain sergeant came to him and wanted to kill him with a stick. He mangled him in a brutish manner, blood was dripping on all sides, when all of a sudden the maltreated boy, who had been lying motionless, jumped to his feet and began to regard, quietly and silently, his cruel murderer with his childish gaze. The sergeant burst into loud cynical laughter, took out his revolver and shot the boy."

From a note-book by a Sonderkommando written in 1943, found in 1952 at Auschwitz-Birkenau
The Holocaust (p. 570) **M. Gilbert**
Ref. W.021

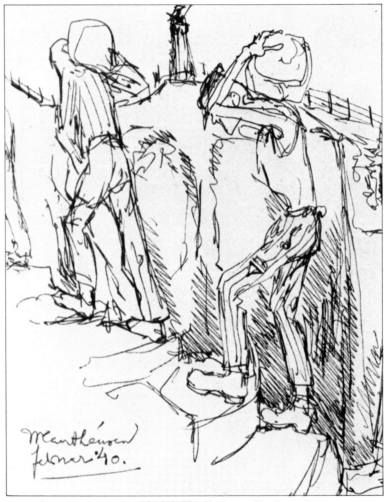

Title: **The Steps of Death** *Author:* **Hans VON BECKER** *In:* Mauthausen *Size:* **19 cm x 16 cm**
Courtesy of: **Dokumentationsarchiv des Österreichischen Widerstandes**
Ref: D.046

" I don't know how I survived. I really don't know how, you see there was this quarry deep down with wide steps - about 100 of them - leading into the pit. We were made to go down and sometimes even the SS themselves loaded these stones on each and every one of us and we had to carry these stones up the one hundred steps to the surface. Just imagine, each man in his starved condition bent double under the heavy boulder that cut into his bones. Often we would collapse under the weight and the stone would go hurtling down, crushing those who were struggling up behind....it was a death trap....I really don't know how I survived."
ĸ

Testimony of Victor (Kushi) GREENBERG
who was in Mauthausen Concentration Camp in 1944.
He now lives in Elstree, Herts, England
Ref. W.022

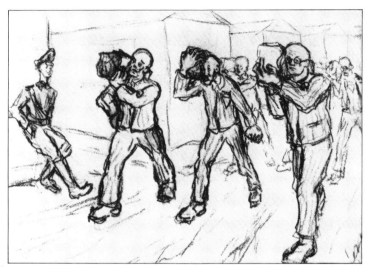

Title: **Work Column** *Author:* **Ernst EISENMAYER** *In:* **Mauthausen, 1944** *Size:* **35 cm x 48 cm**
Courtesy of: **Artist**
Ref: D.047

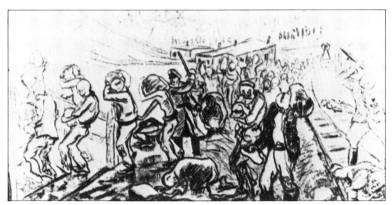

Title: **Work Column** *Author:* **Unknown** *In:* **Buchenwald**
Ref: D.048

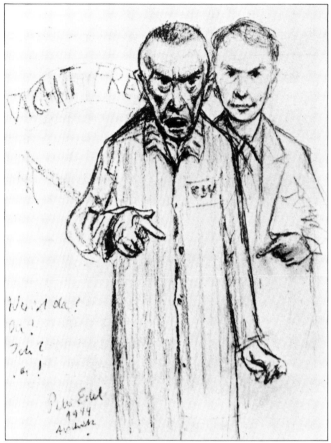

Title: **Self Portrait** *Author:* **Peter EDEL** *In:* **Auschwitz, 1944** *Size:* **30 cm x 20 cm**
Courtesy of: **Auschwitz Memorial Museum**
Ref: D.049

"He asked me - he said: 'Tell me, colleague, when shall I see my wife and children?' I said: 'Why do you ask me this question?' He said to me: 'We were told on the ramp at Birkenau that those who were fit for labour were going to a separate camp, and the women and children would go to another camp in which they would get better treatment; and after two weeks there would be a reunion'. And he asked me: 'When will this reunion take place, and how?'

I told him the truth, but then I was sorry. He told me: 'Small wonder that the Germans accuse the Jews of spreading atrocity stories - it is impossible what you are telling me now!' I showed him the crematoria, a hundred yards outside the camp, and I asked him: 'Do you see that building? What do you think it is?' He said: 'That is a bakery'.

Two weeks later, Dr Beilin saw the Dutch physician again:

He called me. I wanted to evade this meeting. I saw him from afar and he came up to me. It was very embarrassing to me. He said, 'Colleague, you were right. It is murder.'

I later learned from his Dutch colleagues that he had committed suicide by hanging himself. This was the most popular method of committing suicide in Birkenau. He hanged himself on the electrified barbed wire."

Dr Aharon BEILIN's testimony
The Holocaust (p. 539) **M. Gilbert**
Ref: W.023

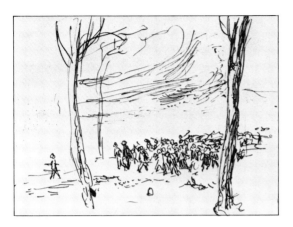

Title: **Return from Work**
Author: **Mieczyslaw KOSCIELNIAK**
In: **Auschwitz, 1943** *Size:* **21 cm x 29.5 cm**
Courtesy of: **Auschwitz Memorial Museum**
Ref: D.050

Title: **Evacuation of Prisoners from Auschwitz**
Author: **Mieczyslaw KOSCIELNIAK**
In: **Auschwitz, 1945** *Size:* **21 cm x 30 cm**
Courtesy of: **Artist**
Ref: D.051

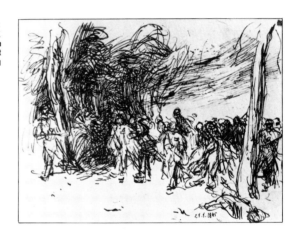

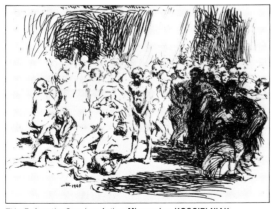

Title: **Before the Gassing** *Author:* **Mieczyslaw KOSCIELNIAK**
In: **Auschwitz, 1945** *Size:* **23 cm x 29.5 cm**
Courtesy of: **Auschwitz Memorial Museum**
Ref: D.052

"In Vilna, the poet Shmerl Kaczerginski was standing not far from the ghetto gate. 'I saw a young fellow sneaking in,' he later recalled, 'bloody, weary, disappearing quickly into a doorway.' In the security of someone's home, the young man then 'pulled off his clothes, washed away the blood, tied up his wounded shoulder', and whispered to those who had crowded around him: 'I come from Ponar!'

Kaczerginski added: 'We were petrified'. The young man told them: 'Everyone - everyone was shot!' The tears rolled down his face. 'Who?' he was asked. Did he mean the four thousand who were being sent to Kovno? 'Yes!'"

KACZERGINSKI's memoirs
The Holocaust (p. 555) **M. Gilbert**
Ref. W.024

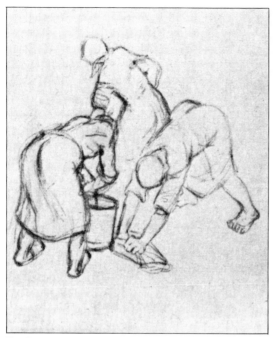

Title: **Cleaning the Floors** Author: **Unknown**
In: **Ravensbrück, 1942** Size: **21 cm x 15 cm**
Courtesy of: **Ravensbrück Museum**
Ref: D.053

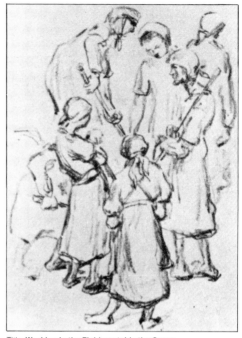

Title: **Working in the Fields outside the Camp**
In: **Ravensbrück, 1942** Size: **20.5 cm x 14.5 cm**
Courtesy of: **Ravensbrück Museum**
Ref: D.054

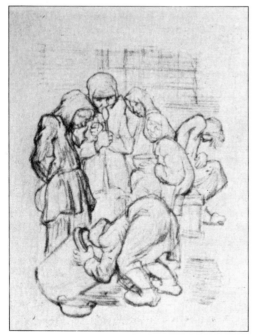

Title: **Food at Midday** In: **Ravensbrück,1942**
Size: **26.5 cm x 21 cm** Courtesy of: **Ravensbrück Museum**
Ref: D.055

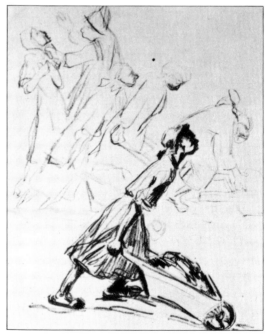

Title: **Work** In: **Ravensbrück, 1942** Size: **26.5 cm x 21 cm**
Courtesy of: **Ravensbrück Museum**
Ref: D.056

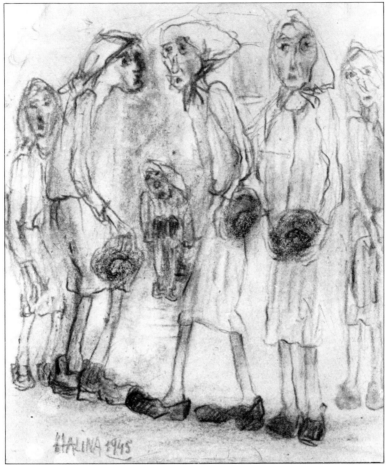

Title: **Waiting for the Soup** *Author:* **Halina OLOMUCKI** *In:* 1945 *Courtesy of:* **Yad Vashem, Jerusalem**
Ref: D.057

"They had been brought to Auschwitz only weeks before, slender, black-eyed against the sleet and cold of the northern October. They sang a sentimental song called 'Mama', whose melody made one weep.

In a few weeks Auschwitz had withered those exotic flowers, their fiery eyes had become dull in sunken sockets, empty and dead. Emaciated, dirty, repulsive, those Greek women could barely drag themselves around. Once so shapely, they now had legs like sticks and their breasts hung like bags. Their complexions, made velvet smooth by the southern sun, were now covered with horrible abscesses, vermin bites, and the marks of scabies incessantly scratched. They stank of gangrene, dysentery, unwashed sweat, and wretchedness.

When they went to their deaths they sang the 'Hatikvah' the song of undying hope, the song of an old people which has always carried the vision of Zion in its heart. Since then, every time I hear 'Hatikvah' I always see them, the dregs of human misery, and I know that through mankind flows a stream of eternity greater and more powerful than individual deaths."

Lena BERG an eye-witness of events in 1943
The Holocaust (p. 621) **M. Gilbert**
Ref. W.025

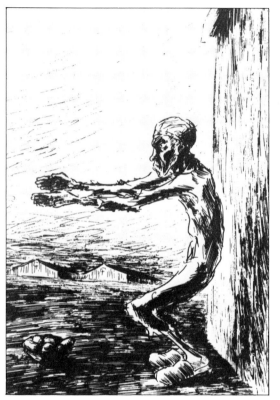

Title: **Torture (i)** Author: **Hans P.SORENSEN** In: **Neuengamme**
Size: **30 cm x 45 cm** Courtesy of: **Danish National Museum**
Ref: D.058

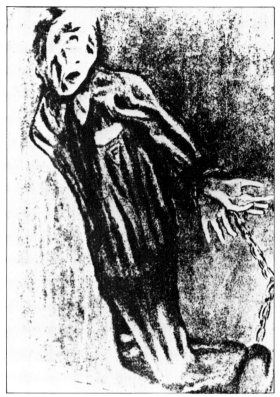

Title: **Torture (ii)** In: **Buchenwald, 1944**
Ref: D.059

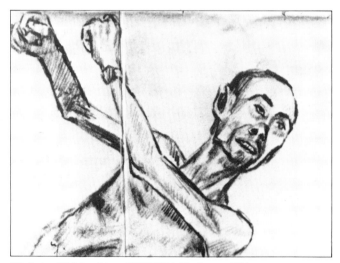

Title: **Torture (iii)** Author: **Edmund GOERGEN** In: **Mauthausen, 1944**
Size: **12.5 cm x 21.5 cm** Courtesy of: **Musée D'Histoire Contemporaine — BDIC**
(Universités de Paris)
Ref: D.060

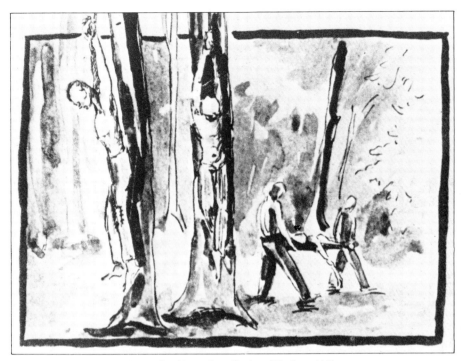

Title: **Torture (iv)** *In:* **Buchenwald, 1944** *Size:* **10 cm x 7 cm** *Courtesy of:* **Buchenwald Museum**
Ref: D.061

"I t was cold. The ground was covered with snow and mud. In such conditions and in the middle of a snow storm a big transport arrived from Zamosc. The whole Judenrat was on the train. When they had all undressed and stood naked, as usual, the men were pushed towards the gas-chambers and the women to the barrack-hut to have their heads shaved. But the leader of the Judenrat was ordered to stay behind in the yard. The Ukrainian guards took the transport away and the complete Belzec SS detachment surrounded the Jewish leader. I don't know his name. I saw a middle-aged man, pale as death, but completely calm.

The SS men ordered the orchestra in the yard to await further orders. The orchestra - six musicians - was usually stationed in the area between the gas-chambers and the mass graves. They played all the time - day after day - using instruments taken from the dead.

I was working nearby on construction work, and saw everthing that happened. The SS ordered the orchestra to play 'Es geht alles voruber, es geht alles vorbei' and 'Drei Lilien' on flutes, fiddles and harmonicas. This lasted for some time. Then they put the leader of the Judenrat against a wall and started to beat him about the head and face with whips. Those who tortured him were Irrmann - a fat Gestapo man - Schwartz, Schmidt and some of the Ukrainian guards.

Their victim was ordered to dance and jump around to the music while being beaten. After some hours he was given a quarter of a loaf of bread and made to eat it - while still being beaten.

He stood there, covered in blood, indifferent, very calm. I did not hear him even groan once. His torment lasted for seven hours, The SS men stood there and laughed, 'Das ist eine hohere Person, Prasident des Judenrates!' They shouted loudly and wickedly.

It was six o'clock in the evening when Gestapo man Schmidt pushed him towards a grave, shot him in the head and kicked the body on to the pile of gassed victims."

On 15 November 1942, Rudolf REDER, a witness
The Holocaust (p. 501) **M. Gilbert**
Ref. W.026

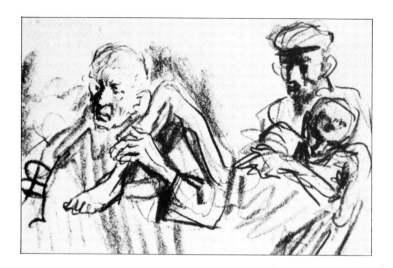

Title: **Back from Work (i)**
Author: **Mieczyslaw KOSCIELNIAK**
In: **Auschwitz, 1942** *Size:* **29 cm x 21 cm**
Courtesy of: **Auschwitz Memorial Museum**
Ref: D.062

Title: **Back from Work (ii)**
Author: **Mieczyslaw KOSCIELNIAK**
In: **Auschwitz-Birkenau, 1942**
Size: **30 cm x 44 cm** *Courtesy of:* **Auschwitz**
Memorial Museum
Ref: D.063

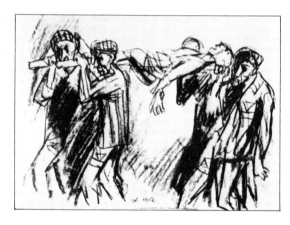

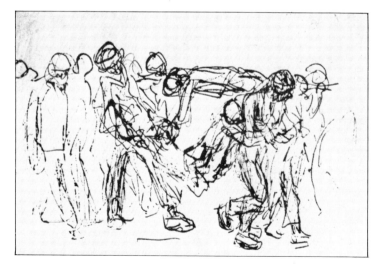

Title: **Back from Work (iii)**
Author: **Mieczyslaw KOSCIELNIAK**
In: **Auschwitz-Birkenau, 1942**
Size: **29 cm x 21 cm** *Courtesy of:* **Auschwitz**
Memorial Museum
Ref: D.064

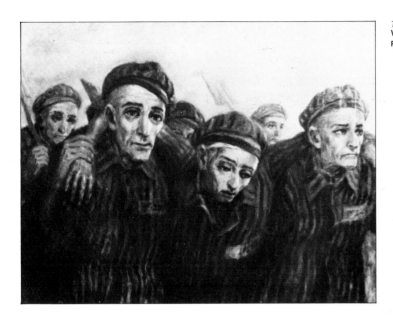

Title: **Back from Work (iv)** *Courtesy of:* **Yad Vashem, Jerusalem**
Ref: D.065

The injured, the ill, the dying and the dead were carried back from work to the camp and laid on the ground for the evening roll-call count.

Ref. W.027

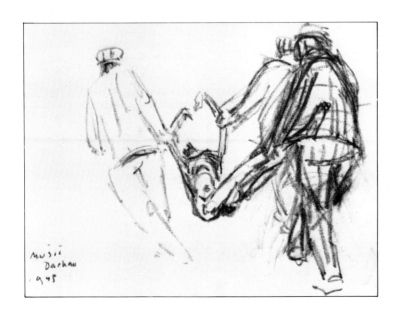

Title: **Back from Work (v)** *Author:* **Zoran MUSIC**
In: **Dachau, 1945** *Size:* **21 cm x 30 cm**
Courtesy of: **Author**
Ref: D.066

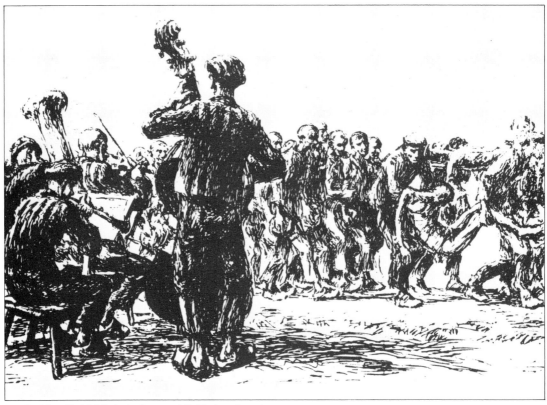

Title: **Back from Work (vi) Orchestra** *Courtesy of:* **Yad Vashem, Jerusalem**
Ref: D.067

Title: **Back from Work (vii) Musician**
Author: **Mieczyslaw KOSCIELNIAK**
In: **Auschwitz, 1943** *Size:* **15 cm x 9 cm**
Courtesy of: **Auschwitz Memorial Museum**
Ref: D.068

Outside the gate music starts to play. Yes, we have an orchestra, made up of sixty men, all inmates. This orchestra, which has some known personalities in the music world in it, always plays when we are going to and from work or when the Germans take a group out to be shot. We know that for many, if not all, of us the music will someday play the "Death Tango," as we call it on such occasions.

Albert H. FRIEDLANDER
Out of the Whirlwind (p. 230)
Ref. W.028

Title: **Working Song, Diary Illustration**
Author: **Karol KONIECZNY** *In:* **Buchenwald,**
1944 *Size:* **17.5 cm x 25 cm**
Ref: D.069

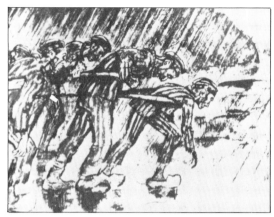

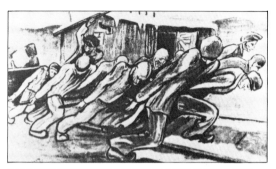

Title: **Labour and Torture (ii)** *Author:* **Pierre MANIA** *In:* **Buchenwald, 1944** *Courtesy of:* **Sachsenhausen Museum**
Ref: D.071

Title: **Labour and Torture (i)** *Author:* **Henri PIECK** *In:* **Buchenwald, 1945**
Courtesy of: **Buchenwald Museum**
Ref: D.070

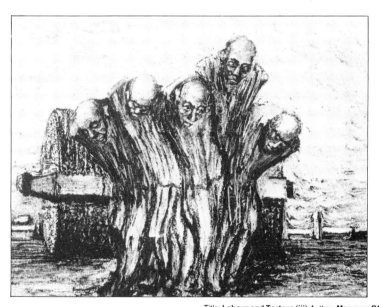

Title: **Labour and Torture (iii)** *Author:* **Maurycy BROMBERG**
Courtesy of: **Jewish Historical Institute**
Ref: D.072

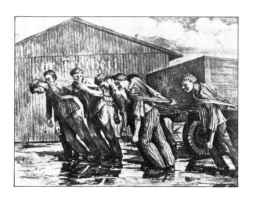

Title: **Labour and Torture (iv)** *Author:* **Odd NANSEN** *In:* **1944**
Courtesy of: **Sachsenhausen Museum**
Ref: D.073

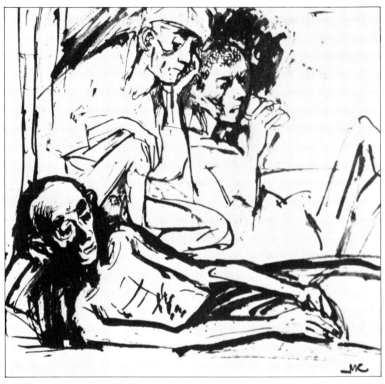

Title: **Prisoners** *In:* **Auschwitz, 1942**
Size: **33 cm x 30 cm** *Courtesy of:* **Artist**
Ref: D.074

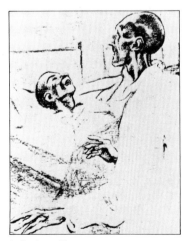

In: **Buchenwald**
Ref: D.075

"The SS men were watching the nurses with a respect they seldom showed for anybody, hoping that the nurses would be 'selected' to remain in the barracks. 'We could use some decent medical help around here,' one of them commented. But the doctor making the selection - his name is not known - decided that the nurses must die.

Vrba noted:

One of the SS officers shrugged and shouted, 'Get the girls aboard! It seems they've got to go, too.' The nurses climbed up after their patients. The lorry engines roared and off they swayed to the gas-chambers.' Not a single nurse, nor a single patient, survived."

1943 Auschwitz-Birkenau,
Transport from Apeldorn, eye-witness account by Rudolf VRBA.
The Holocaust (p. 599) **M. Gilbert**
Ref: W.029

In: **Mauthausen** *Courtesy of:* **Lie Caly Omre, published by Ksiazka i Wiedza, 1975**
Ref: D.076

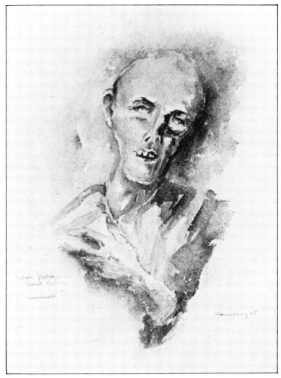

In: **Buchenwald**
Ref: D.077

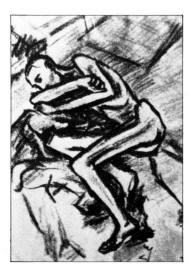

Title: **Hungarian Youth in Agony**
Author: **Edmund GOERGEN**
In: **Mauthausen, 1944** *Size:* **21.5 cm x 15 cm**
Courtesy of: **Musée D'Histoire Contemporaine**
— BDIC (Universités de Paris)
Ref: D.078

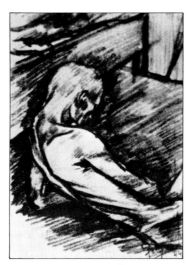

Title: **Italian: Study of a Corpse**
Author: **Edmund GOERGEN**
In: **Mauthausen, 1944** *Size:* **21.5 cm x 15 cm**
Courtesy of: **Musée D'Histoire Contemporaine**
— BDIC (Universités de Paris)
Ref: D.079

41

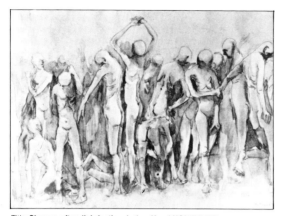

Title: **Shower, after disinfection** Author: **Karol KONIECZNY**
In: **Buchenwald, 1945** Size: **20 cm x 28 cm**
Courtesy of: **Buchenwald Museum**
Ref: **D.080**

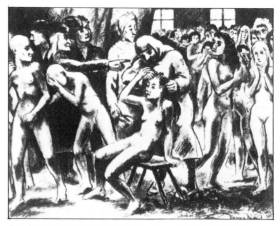

Title: **Shorn** Author: **France AUDOUL** In: **Ravensbrück, 1944 - 1945**
Courtesy of: **FNDIRP, Paris**
Ref: **D.082**

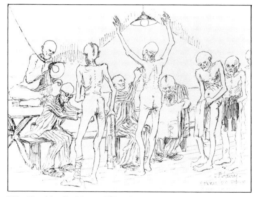

Title: **Checking for Lice and Shaving of Hair**
Author: **Auguste FAVIER** In: Buchenwald,
1944 Courtesy of: **Robert FAVIER, France**
Ref: **D.081**

"But as a survivor myself I can at least testify that most of those who have survived went through that 'universe' (the concentration camp 'universe') with withdrawn antennae, divorced from truth, from reality, from normal human and humane values, substituting those with a different code and rituals, which now may look crazy or perverted; the choice, in order to survive, was: losing one's humanity or inventing a new one, losing one's dignity or inventing new symbols to keep it. One went on by forgetting immediately what had been done to one or what one had done the day before, thus being able to face the next blow.

For many, all that was left of their human countenance was a feeling of shame for being able to suffer what others were not; to survive what others did not; and be tormented by an eternal question - did one outlive the others because one was less sensitive, or even worse, did one live in some way at the expense of the death of others? There is hardly a survivor, articulate or not, who does not feel persecuted and accused by his dead companions, or who in the deepest chamber of his soul does not feel his own staying alive vis-a-vis dying, as only temporary reprieve. In that sense, one has not at all rejoined the world of the living; one is here merely waiting the final call."

Vera ELIYASHIV b.1929
Lithuanian writer. Survived the concentration camps.
Settled in London in 1963.
© Reform Synagogues of Great Britain
- High Holyday Machzor, Forms of Prayer
- Days of Awe, 1985
Ref. W.030

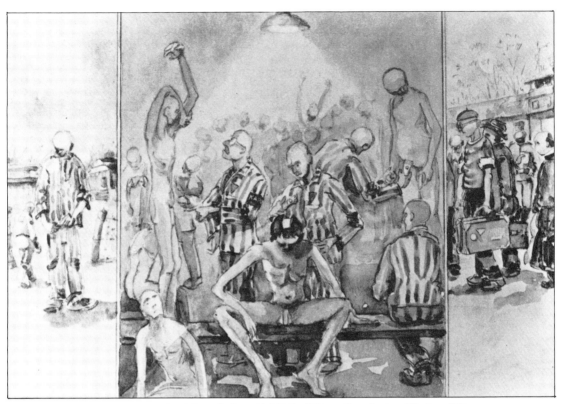

Title: **Arrival/Showers/Camp** *Author:* **Karol KONIECZNY** *In:* **Buchenwald, 1945** *Size:* **22.5 cm x 30 cm** *Courtesy of:* **Buchenwald Museum**
Ref: D.083

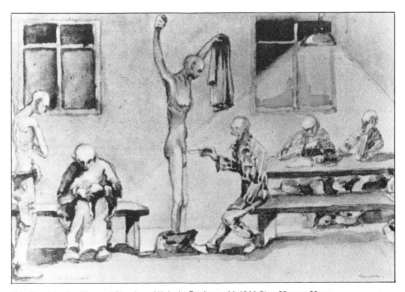

Title: **Checking for Lice and Shaving of Hair** *In:* **Buchenwald, 1944** *Size:* **22 cm x 29 cm**
Ref: D.084

Title: **Inmate of the Ghetto** *Author:* **Hersz SZYLIS** *In:* **Lodz Ghetto, 1942**
Courtesy of: **Yad Vashem, Jerusalem**
Ref: D.085

E ach man has a name
given him by God
and given him by his father
and mother.

Each man has a name
given him by the stars
and given him by his neighbours.

Each man has a name
given him by those who hate him
and given him by his love.

Zelda MISHKOWSKY (1914 - 1984)
Hebrew Poetess born in the Ukraine,
Extracts of her poetry *Translation J. Magonnet*

© Reform Synagogues of Great Britain
- High Holyday Machzor, Forms of Prayer
- Days of Awe, 1985
Ref. W.031

Title: **Portrait of Janek, Age 15**
Author: **Franciszek JAZWIECKI**
In: **Sachsenhausen, 1944**
Size: **45 cm x 20 cm**
Courtesy of: **Auschwitz Memorial Museum**
Ref: D.086

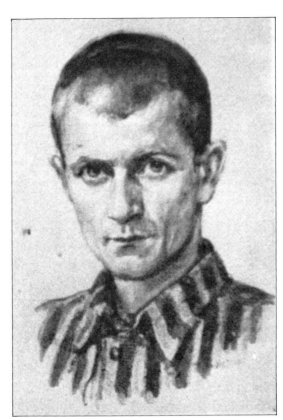

Title: **Self-Portrait** *Author:* **Mieczyslaw KOSCIELNIAK**
In: **Auschwitz, 1943** *Size:* **12.5 cm x 8.7 cm**
Courtesy of: **Auschwitz Memorial Museum**
Ref: D.087

Title: **Woman** *In:* **Auschwitz, 1944**
Size: **22.5 cm x 11 cm**
Courtesy of: **Lie Caly Omre, published by**
Ksiazka i Wiedza, 1975
Ref: D.088

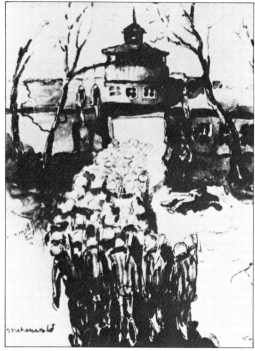

Amongst these deportees was the fifteen-year-old Yaakov Biskowitz. From the transport of 3,400, only twelve were selected for work: Biskowitz and his father among them. They were put to work as carpenters. All the other Hrubieszow deportees were gassed in Camp 3.

Hava FOLLMAN and Frumka PLOTNICKA
deported to Sobibor (1942)
The Holocaust (p. 361) **M. Gilbert**
Ref. W.032

Title: **Returning from Work** *In:* **Buchenwald, 1945** *Size:* **22 cm x 29 cm**
Courtesy of: **Buchenwald Museum**
Ref: **D.089**

One of the men working near me was a weak-looking individual who — while the more experienced prisoners picked out huge flat stones that looked impressive, but weighed little — picked up only small stones, ignoring his neighbors' advice. Eventually the foreman noticed him and made him pick up an enormous rock. The man bent under its weight and said apologetically, "I can't carry anything heavy, I have a hernia."

"What's he saying?" Dziobaty was suddenly next to the foreman.

The foreman told him.

"Oh, a hernia, *ruptur,*" the SS man said sympathetically. To the prisoner he said, "Show me, I've never seen one."

Flattered by the SS man's interest, the prisoner complied and lowered his trousers. The SS man bent forward, then swung his foot back and with all his might kicked the man in the genitals with his hobnailed boot. The animal shriek that resounded froze the whole column and faces of curious camp officials appeared in front of every barrack. Blood poured from the body of the prisoner, who now lay writhing on the ground, howling like a dog. "You shitty asshole, you goddam Jew parasite He's got a rupture!" The body finally lay still.

Alexander DONAT
The Holocaust Kingdom (p. 208)
Ref. W.033

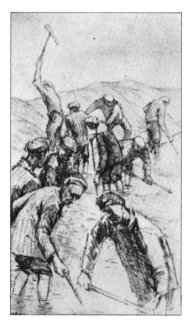

Title: **Digging Ditches**
Author: **Wlodzimierz SIWIERSKI**
In: **Auschwitz, 1941** *Size:* **9 cm x 11 cm**
Courtesy of: **Auschwitz Memorial Museum**
Ref: **D.090**

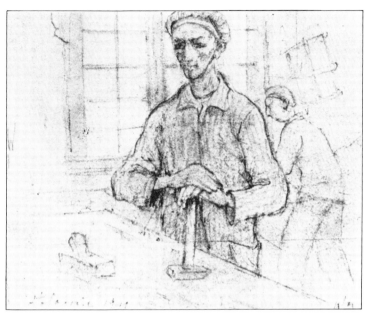

Title: **The Carpenters Workshop** *Author:* **Wlodzimierz SIWIERSKI** *In:* **Auschwitz, 1941**
Size: **10 cm x 12 cm** *Courtesy of:* **Auschwitz Memorial Museum**
Ref: D.092

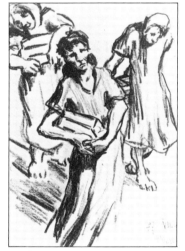

Title: **Stone Carriers**
Author: **Maria HISZPANSKA-NEUMANN**
In: **Ravensbrück, 1944**
Size: **21.5 cm x 15 cm**
Courtesy of: **Bogna Neumann**
Ref: D.091

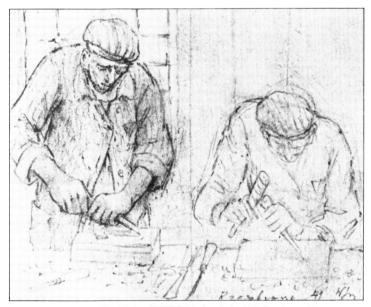

Title: **The Carvers** *Author:* **Wlodzimierz SIWIERSKI** *In:* **Auschwitz, 1941** *Size:* **9 cm x 11 cm**
Courtesy of: **Auschwitz Memorial Musuem**
Ref: D.093

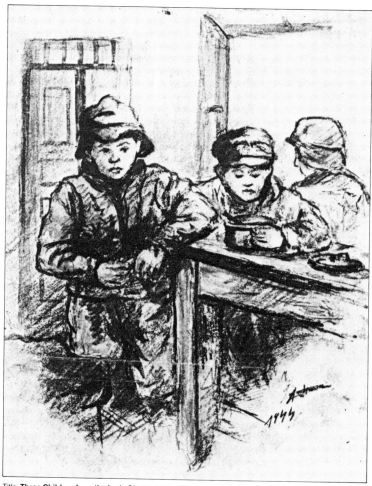

Title: **Three Children from the Lodz Ghetto** *Author:* **Amos SZWARC** *In:* **Lodz, 1944**
Courtesy of: **Beit Loamei Haghetaot**
Ref: D.094

" I did not learn this lesson about faith in a theological college, that came much later, but in miserable little concentration camp in German Silesia, grotesquely called Lieberose, 'Lovely Rose'. It was the cold winter of 1944 and although we had nothing like calendars, my father, who was my fellow prisoner there, took me and some of our friends to a corner of the barrack. He announced that it was the eve of Chanukah, produced a curious-shaped clay bowl, and began to light a wick immersed in his precious, but now melted, margarine ration. Before he could recite the blessing, I protested at this waste of food. He looked at me - then at the lamp - and finally said: 'You and I have seen that it is possible to live up to three weeks without food. We once lived almost three days without water; but you cannot live properly for three minutes without hope!'"

Rabbi Hugo GRYN
© Author
Ref. W.034

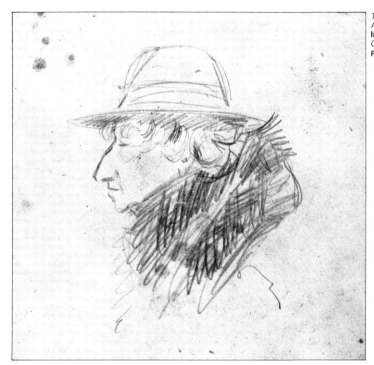

Title: **Portrait**
Author: **Marianne GRANT, formerly Mausi Hermann**
In: Theresienstadt, 1945
Courtesy of: **Author**
Ref: D.095

Title: **Women from Austria and Germany in the**
mock cafés in Theresienstadt, 1943
Author: **Marianne GRANT, formerly Mausi Hermann**
In: **Theresienstadt, 1945** *Courtesy of:* **Author**
Ref: D.096

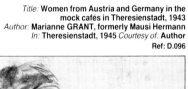

"One day he told a story about the 'stupid Jews': a transport of naked women was brought into the 'bath house'. One woman saw Bauer as he stood on the roof, waiting for the doors to be hermetically sealed so that he could order that the gas taps be opened. The woman stopped the armed soldier who stood by the entrance door and asked him, 'What's the officer in uniform doing on the roof? Is something wrong? How can we wash ourselves here inside while they're fixing the roof?'

The guard pacified her, saying that in just a moment the roof would be fixed and, as for her, she need not hurry to push herself inside; there would be enough room for her too.

This was Bauer's story about the naive Jewess. At the end of his story Bauer dissolved in laughter; he even succeeded in infecting the camp commander and the officers around the casino with his laughter."

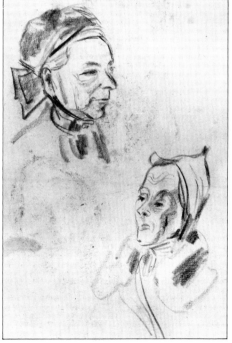

Moshe SHKLAREK recalling events at Sobibor, 1942
The Holocaust (pp. 326-327) **M. Gilbert**
Ref. W.035

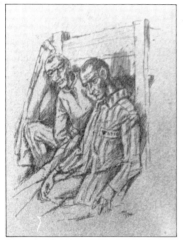

Title: **Inmates / Block 3a**
Author: **Mieczyslaw KOSCIELNIAK**
In: **Auschwitz, 1944** *Size:* **18.5 cm x 14.5 cm**
Courtesy of: **Auschwitz Memorial Museum**
Ref: D.097

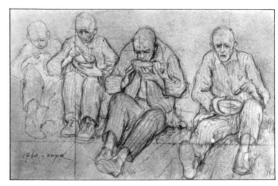

Title: **Break for Soup** *Author:* **Wlodzimierz SIWIERSKI**
In: **Auschwitz, 1940** *Size:* **10 cm x 16.5 cm**
Courtesy of: **Auschwitz Memorial Museum**
Ref: D.099

Title: **Few Moments Repose**
Author: **Wlodzimierz SIWIERSKI**
In: **Auschwitz, 1941**
Size: **10 cm x 12 cm**
Courtesy of: **Auschwitz Memorial Museum**
Ref: D.100

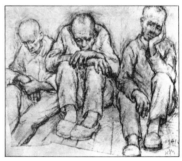

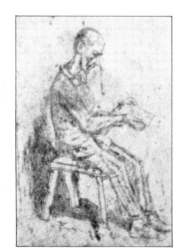

Title: **Letter from Home**
Author: **Mieczyslaw KOSCIELNIAK**
In: **Auschwitz-Birkenau, 1944**
Size: **14 cm x 10 cm** *Courtesy of:* **Auschwitz Memorial Museum**
Ref: D.098

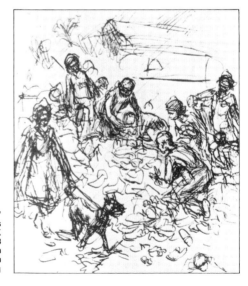

Title: **"Canada Kommando"**
Sorting of Clothes from Victims
Author: **Mieczyslaw KOSCIELNIAK**
In: **Auschwitz-Birkenau, 1943**
Size: **29 cm x 21 cm**
Courtesy of: **Auschwitz Memorial Museum**
Ref: D.101

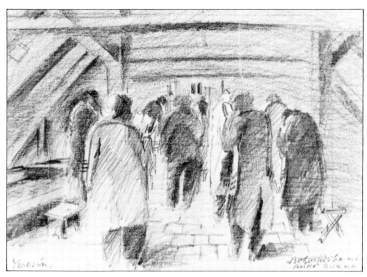

Title: **The Meminyan** *Author:* **Jan BURKA** *In:* **Theresienstadt Ghetto**
Courtesy of: **Yad Vashem, Jerusalem**
Ref: D.102

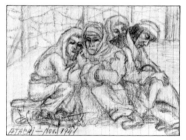

Title: **Huddling Together**
Courtesy of: **Yad Vashem, Jerusalem**
Ref: D.103

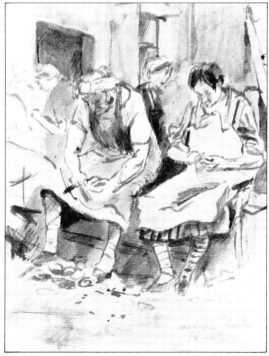

Title: **Potato Peelers**
Courtesy of: **Yad Vashem, Jerusalem**
Ref: D.104

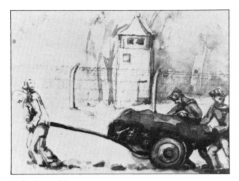

In: **Buchenwald**
Ref: D.105

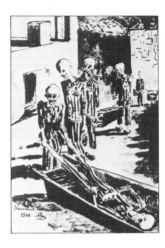

Title: **Carrying Away the Dead**
Author: **Stefan HORSKI**
In: **Sachsenhausen, 1944**
Size: **23 cm x 15 cm**
Courtesy of: **Yad Vashem, Jerusalem**
Ref: D.107

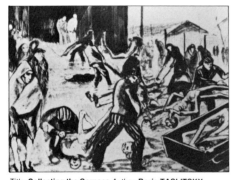

Title: **Collecting the Corpses** Author: **Boris TASLITSKY**
In: **Buchenwald** Courtesy of: **Yad Vashem, Jerusalem**
Ref: D.106

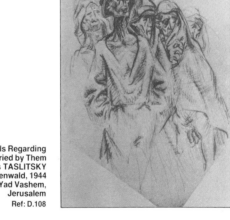

Title: **New Arrivals Regarding a Corpse Carried by Them**
Author: **Boris TASLITSKY**
In: **Buchenwald, 1944**
Courtesy of: **Yad Vashem, Jerusalem**
Ref: D.108

The squad's first task was to remove corpses from a train which arrived that afternoon from Miedzyrzec. 'Eighty per cent of its human cargo consisted of corpses,' he later recalled. 'We had to carry them out of the train, under the whip-lashes of the guards.

The work was very hard, because we had to drag each corpse, in teams of two, for a distance of approximately three hundred metres.

Next to nearly every one of us there was either a German with a whip or a Ukrainian armed with a gun. As we worked, we would be hit over the head.'

Jankiel VIERNIK's testimony
The Holocaust (p. 432-434) **M. Gilbert**
Ref: W.036

"In some of the trucks nearly half the occupants were dead or dying, more than I had ever seen. Many obviously had been dead for several days, for the bodies were decomposing and the stench of disintegrating flesh gushed from the open doors.

This, however, was no novelty to me. What appalled me was the state of the living. Some were drooling, imbecile, live people with dead minds. Some were raving, tearing at their neighbours, even at their own flesh. Some were naked, though the cold was petrifying; and above everything, above the moans of the dying or the despairing, the cries of pain, of fear, the sound of wild, frightening, lunatic laughter rose and fell."

Rudolph VRBA's testimony
The Holocaust (p. 528) **M. Gilbert**
Ref: W.037

"How did you die, dear father? What thoughts crossed your mind as your brief thirty-eight years were extinguished here in Riga? Did the bullets find their mark quickly or did you suffer for interminable moments in agony? Where are your remains, where are they, where are they — I'll never know."

Jules LIPPERT's testimony returning to Riga, 1976
The Holocaust (p. 821) **M. Gilbert**
Ref. W.038

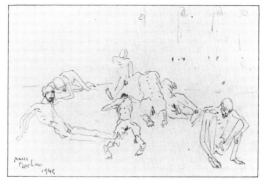

Title: **Living Corpses** *Author:* **Zoran MUSIC** *In:* Dachau, 1945
Courtesy of: **Author**
Ref: D.109

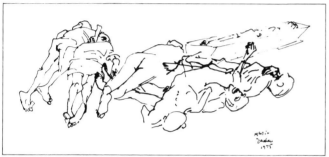

Title: **Corpses** *Author:* **Zoran MUSIC** *In:* Dachau, 1945
Courtesy of: **Author**
Ref: D.110

Title: **Overseeing the Extraction of Gold Teeth from Corpses**
Author: **Zoran MUSIC** *In:* Dachau, 1945 *Courtesy of:* **Author**
Ref: D.111

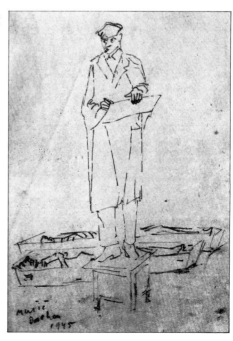

In all the camps bodily cavities were searched for hidden valuables, and gold teeth were extracted from the mouths of the dead. In Crematorium II (new number) at Birkenau, the fillings and gold teeth, sometimes attached to jaws, were cleaned in hydrochloric acid, to be melted into bars in the main camp. At Auschwitz the hair of the women was cut off after they were dead. It was washed in ammonium chloride before being packed. The bodies could then be cremated.

The Destruction of the European Jews, Volume III
(p. 976) **Raul Hilberg**
Ref: W.039

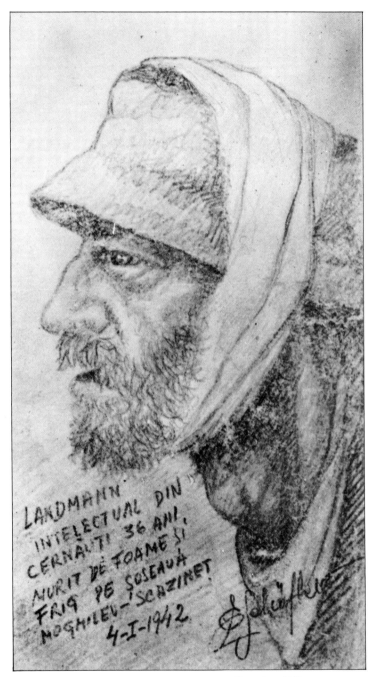

Title: **A Scholar From Czernowitz** Author: **Ervyn SCHIEFLER** In: **Transnistra, 1942**
Courtesy of: **Yad Vashem, Jerusalem**
Ref: **D.112**

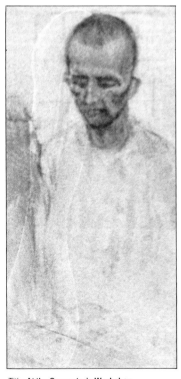

Title: **At the Carpenter's Workshop**
Author: **Wlodzimierz SIWIERSKI**
In: **Auschwitz, 1941** Size: **19.4 cm x 9.5 cm**
Courtesy of: **Auschwitz Memorial Museum**
Ref: **D.113**

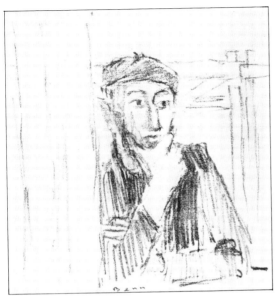

Title: **Monsieur Aisenstein** *Author:* **BENN** *In:* **Beaune la Rolande, 1941**
Courtesy of: **Author**
Ref: D.114

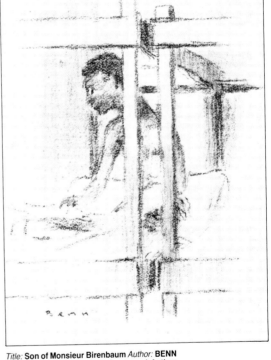

Title: **Son of Monsieur Birenbaum** *Author:* **BENN**
In: **Beaune la Rolande, 1941** *Courtesy of:* **Author**
Ref: D.116

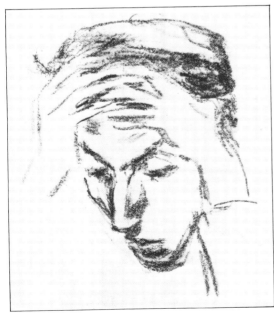

Title: **Despair** *Author:* **BENN** *In:* **Beaune la Rolande, 1941**
Courtesy of: **Author**
Ref: D.115

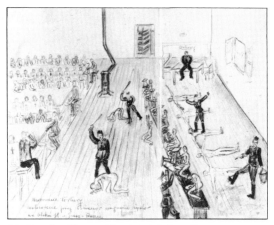

Title: **Memories of Torture of New-Arrivals in Gross-Rosen**
Author: **Ludwig SUROKOWSKI** *In:* **Mauthausen, 1944**
Courtesy of: **Republik Österreich Bundesministerium für Inneres Archiv des Öffentlich Denkmals und Museums Mauthausen**
Ref: D.117

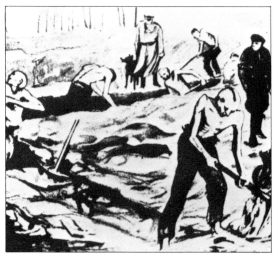

In: **Buchenwald**
Ref: D.118

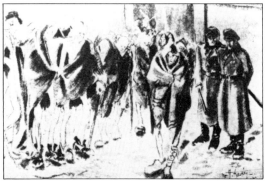

In: **Buchenwald**
Ref: D.119

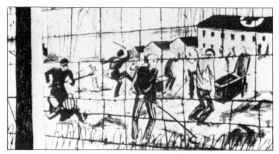

In: **Buchenwald**
Ref: D.120

"Then the 'game' started. We could hear the sound of a man, clearly one of us, stumbling awkwardly around, chased and beaten by another as he went. At last the pursued collapsed out of sheer exhaustion. He was told to rise. Blows were rained down upon him until he dragged himself to his feet again and tried to run forward. He fell to the ground again and hadn't the strength to get up. When the pursuers were at last satisfied that the incessant blows had rendered him unable to stir, let alone run, they called a halt and left him there. Now it was the turn of a second victim. He received the same treatment.

Now a third was hauled out. The Germans, in pursuit of their sport, tramped up and down over our backs as we lay there. No one dared to raise his head."

Leon WELICZKER, eye-witness
The Holocaust (p. 164-165) **M. Gilbert**
Ref: W.040

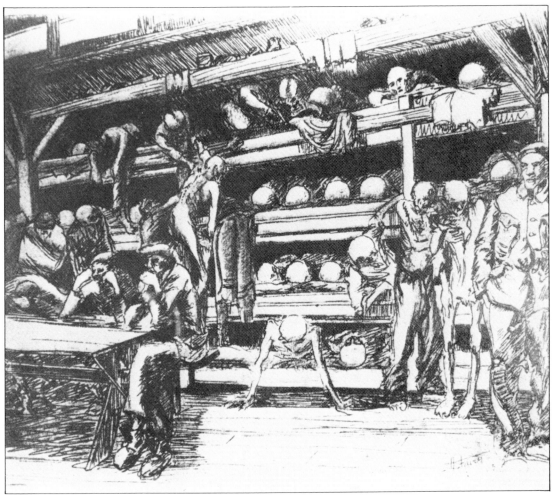

Title: **Block in the Little Camp** *Author:* **Auguste FAVIER** *In:* **1943**
Courtesy of: **Robert FAVIER coll., Rouen**
Ref: D.121

'Men and women, clad in rags, and barely able to move from starvation and typhus, lay in their straw bunks in every state of filth and degradation. The dead and dying could not be distinguished.' Men and women 'collapsed as they walked and fell dead.'

The Holocaust (p. 792) **M. Gilbert**
Ref. W.041

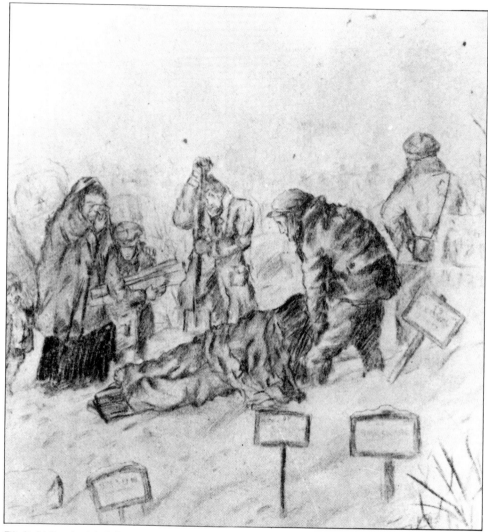

Title: **Jewish Cemetery in Lodz** *Author:* **Amos SZWARC** *In:* **Lodz Ghetto, 1943** *Courtesy of:* **Yad Vashem, Jerusalem**
Ref: D.122

"Deliberately, in order not to trample the skulls and not to slip into an open grave, we made our way through this place of rest to the spot where my father's bones had lain. Though the location was well known to me, I could not find his grave. The spot was desolate, destroyed, the soil pitted and strewn with broken skulls and markers.

We stood there forlorn. Around our feet lay skull after skull. Was not one of them my own father? How would I ever recognize it?

Nothing. Nothing was left me of my past, of my life in the ghetto - not even the grave of my father."

Vladka MEED née Feigle PELTEL's recollections
Both Sides of the World
Ref. W.042

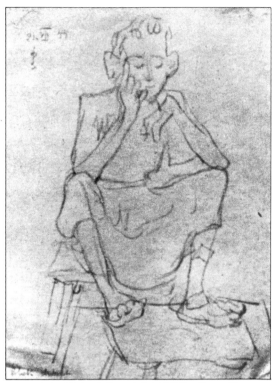

Title: **Boy in the Sick Bay** *In:* **Ravensbrück, 1944** *Size:* **21 cm x 15 cm**
Courtesy of: **Ravensbrück Ex-Prisoners Association**
Ref: D.123

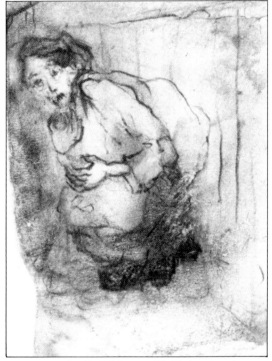

Title: **Smuggling Food** *In:* **1943** *Courtesy of:* **Yad Vashem, Jerusalem**
Ref: D.124

A few Jews had managed to hide in Buchenwald during the 'evacuation' of April 8. One of them, Israel Lau, was only eight years old. He had been kept alive by the devotion and ingenuity of his elder brother, Naftali, aged nineteen. Three days after most of the Jews had been marched out of the camp, American forces arrived. One of the American officers, Rabbi Herschel Schechter, later recalled how he pulled a small, frightened boy from a pile of corpses. The rabbi burst into tears and then, hoping to reassure the child, began to laugh.

'How old are you?' he asked Israel Lau, in Yiddish. 'Older than you.'
'How can you say that?' asked the rabbi, fearing the child was deranged.
'You cry and laugh like a little boy,' Lau replied, 'but I haven't laughed for years and I don't even cry any more. So tell me, who is older?'

The Holocaust (p. 792) **M. Gilbert**
Ref. W.043

Title: **In the Camp — Conversation**
Ref: D.125

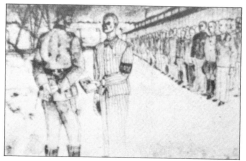

Title: **Roll Call**
Ref: D.126

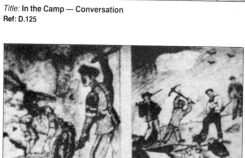

Title: **Flogging — At Work**
Ref: D.127

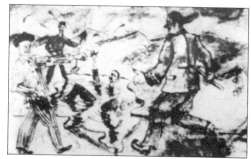

Title: **Sadistic Punishment**
Ref: D.128

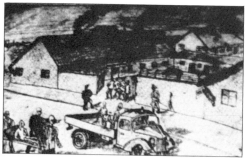

Title: **Birkenau: Blocks 7 & 8**
Ref: D.129

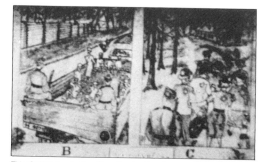

Title: **On the way to Gas Chamber I — Gas Chamber II**
Ref: D.130

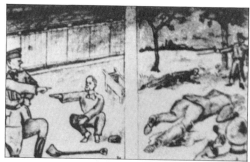

Title: **"Go on! Squat!" — "Go on! Fall!"**
Ref: D.131

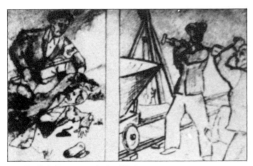

Title: **Sadistic Treatment during Work**
Ref: D.132

Title: **Working on the Ramp**
Ref: D.133

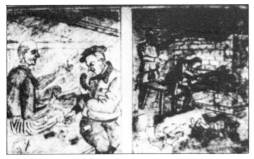

Title: **Organization**
Ref: D.134

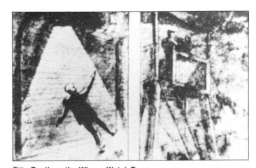

Title: **Death on the Wire — Watch Tower**
Ref: D.135

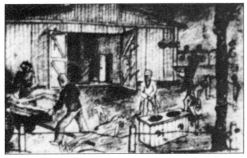

Title: **The Sick-Bay Block**
Ref: D.136

Title: **The SS Car**
Ref: D.137

Title: **Shooting at the Prisoner — Hanging the Prisoner**
Ref: D.138

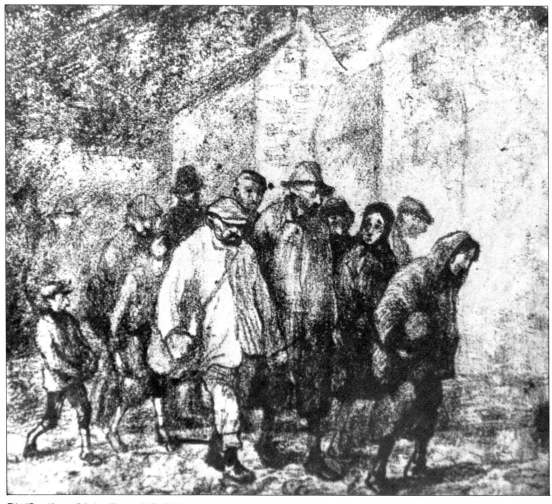

Title: **"Resettlement"** *Author:* **Krzysztof HENISZ** *Courtesy of:* **Warsaw Historical Institute**
Ref: D.139

P eople were taken out of their flats, some carrying a
few of their possessions, some without any posses-
sions, out of all the courtyards, out of all the flats, they
were driven out with cruel beatings.

Abba KOVNER'S testimony
The Holocaust (p. 192) **M. Gilbert**
Ref: W.044

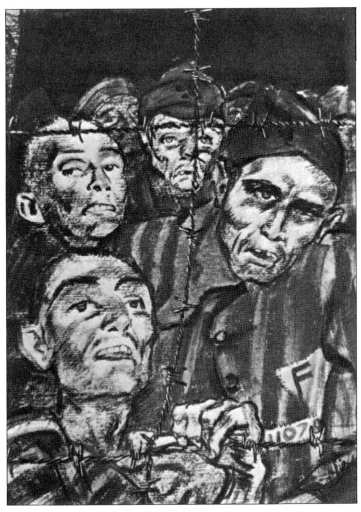

Title: **Behind Barbed Wire** *Author:* **Henri PIECK** *In:* **Buchenwald**
Courtesy of: **Yad Vashem, Jerusalem**
Ref: D.140

On April 15, the first British tanks entered Belsen. By chance, three of the British soldiers in the tanks were Jews. But the survivors did not realize what had happened: 'We, the cowed and emaciated inmates of the camp, did not believe we were free,' one of the Jews there, Josef Rosensaft, later recalled. 'It seemed to us a dream which would soon turn again into cruel reality.'

The Holocaust (p. 793) **M. Gilbert**
Ref. W.045

Page

Page

(continued overleaf)

* *The Holocaust, The Jewish Tragedy* by Martin Gilbert, published in paperback by Fontana, 1987